D0548356

The THINKING
PHOTOGRAPHER

The THINKING PHOTOGRAPHER

IAN BRADSHAW

Macdonald

A *Macdonald* BOOK

First published in Great Britain in 1986
by Macdonald & Co (Publishers) Ltd
London & Sydney

A member of BPCC plc

© Marshall Editions Limited 1986

All rights reserved
No part of this publication may be
reproduced, stored in a retrieval system,
or transmitted, in any form or by any
means without the prior permission in
writing of the publisher, nor be
otherwise circulated in any form of
binding or cover other than that in
which it is published and without
a similar condition including this
condition being imposed on the subsequent
purchaser.

British Library Cataloguing in
Publication Data
Bradshaw, Ian
 The thinking photographer.
 1. Photography
 I. Title
 770′.28 TR146
 ISBN 0-356-12153-4

Filmset by Filmtype Services Limited,
Scarborough, North Yorkshire
Origination by Gilchrist Brothers Limited,
Leeds
Printed and bound in Belgium by Usines
Brepols SA

Macdonald & Co (Publishers) Ltd
Maxwell House
74 Worship Street
London EC2A 2EN

Conceived, edited and designed by
Marshall Editions Limited,
170 Piccadilly, London W1V 9DD

Art Director **John Bigg**
Text Editor **Judy Garlick**
Assistant Editors **Carole Devaney**
 Gwen Rigby
Assistant Designer **Pauline Faulks**
Managing Editor **Ruth Binney**
Production **Barry Baker**
 Janice Storr

Photographs by the author
Additional photography by
Jennifer Allsopp

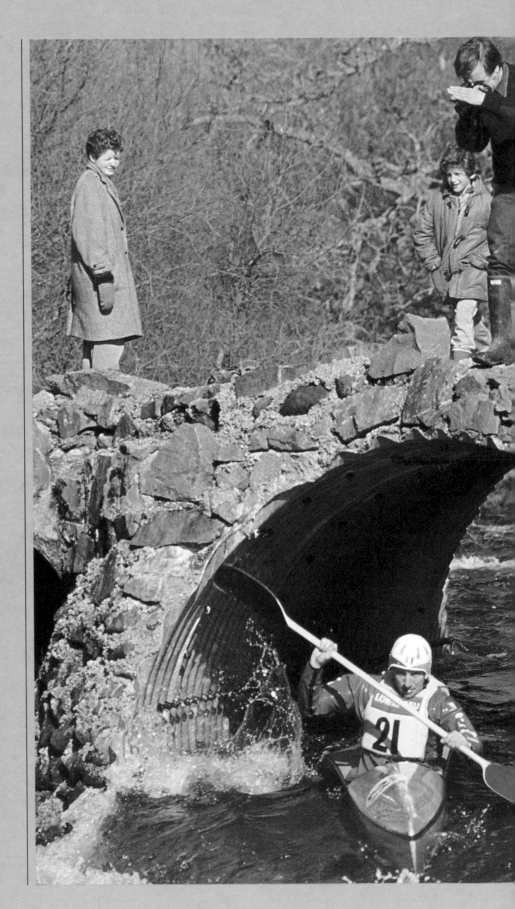

Contents

STOP! THINK!

Photography is becoming easier: modern technology now makes it possible for anyone with a camera to take perfectly exposed, sharp pictures. Some cameras even speak, reminding you to load the film. But whether you own a simple camera or a case full of expensive equipment, whether you are a beginner or an experienced professional, you can improve your pictures by thinking clearly and creatively.

WHO? WHAT? WHERE? WHEN? WHY? and HOW? were once the key words of the great detectives. Applied to photography, the answers to these questions can turn an absolute beginner into a thinking photographer. This book does not tell you which camera to buy or even what equipment you need. But it does tell you how to improve your photographs by thinking clearly and asking the right questions.

Whether the subject is portraiture, children, still-life, weddings, photojournalism, sport, glamour, landscapes, travel, animals or architecture; whether you are taking your first picture or your thousandth, the same rules apply. This book tells you how to anticipate, interpret and execute your photographs creatively. Many of the situations described have been photographed to illustrate the thinking process in particular rather than photographic techniques in general. Often they show the photographer at work as well as the final results.

Developing the knack

The thought processes outlined in a section of this book may be up to eight pages long, showing the development of an idea from bad through to good, or even great. These thoughts flash through the mind of an experienced photographer almost intuitively, in seconds.

I approach all my assignments in the same way: plan as much as possible. Research and anticipate, but always expect the unexpected. I try to view a situation as if I were an infinitely variable zoom lens — from extreme wide angle to super telephoto; standing back to view the overall picture or closing in on a small detail; looking up, down and from the side.

There is one golden rule that every photographer should follow: keep it simple. The best ideas are the simple ones. The more complicated the concept, the more confusing the image. All the great photographs taken over the years have been simple and uncluttered.

That basic simplicity has been applied to the preparation of this book. There are no long, theoretical essays — just the photographs, together with concise advice keyed to the pictures. Although I have tried to keep the text uncomplicated, there are inevitably a few technical terms unfamiliar to the beginner. There is a glossary at the back of the book that explains them.

In one section, six photographers with widely differing styles are given a model in a bare room, a camera with a standard lens, a flash, a tripod and a choice of film. The results show how different people see the same subject. By the same token, there are no absolute guidelines for good or bad in photography. People see things differently and their appreci-

ation is largely a matter of personal opinion. As reader and photographer, you may or may not agree with the views expressed here. But to form any opinions at all you must think, and that is exactly what this book is all about.

What makes a good picture?
Answer the questions WHO? WHAT? WHERE? WHEN? WHY? and HOW? and a good picture is not far away. But there are no absolutes in photography. Personal opinions differ, and what one person loves another may loathe. Even among professionals there is a wide variety of taste and preference. There are many photographs, however, that a large cross-section of people agree are good or even great. Such pictures have a visual impact that catches the eye of even the most casual observer. Photographs such as the Streaker at Twickenham (see p. 20) do not happen often but they become known worldwide.

The thinking process
So just what makes a good photograph and how do you take one? Nearly all great photographs are essentially simple with a strong focal point. Design is also important, and the eye must be led to that point.

Most of the photographs in this book owe their success to thought and creativity, not to unusual lenses and advanced techniques. Many were taken using lenses within the standard focal length range. The pictures work because they have been thought out, sometimes with careful advance planning, other times by fast-thinking opportunism. They are nearly all basically simple and uncomplicated by technical know-how.

Most photographs are taken in colour these days, but some work much better in black and white — indeed they positively cry out for this more graphic technique. It is well known, for example, that human tragedy and wars lose their impact in colour. Larry Burrows' brilliant coverage of the war in Vietnam was stark and chilling in black and white. When the pictures were published in colour, they not only lost their impact but even made a field littered with dead bodies look almost pretty. The thinking process thus extends to film as much as to camera angles and subject matter.

Thinking is also essential in choosing equipment. It makes little economic sense to buy an expensive lens if you will use it only once or twice a year. The fisheye lens for the shot of St Paul's Cathedral (see p. 18) was hired for the occasion. You do not need a soft-focus filter when you can breathe on the lens or shoot through crumpled cellophane and get the same effect.

Contrary to popular belief, equipment is not the most important factor in taking a good picture. While many amateurs bedeck themselves with the 'jewellery' of the trade, most professionals strive to lighten their load. Even if you have every lens and filter on the market, if you can't think, you can't shoot.

The following pages illustrate the thinking approach to the six key questions.

IAN BRADSHAW

WHO?

In portraiture WHO? is always a key question, but it is not necessarily the only one the photographer has to answer successfully. In this instance, it was the responses to WHERE? and HOW? that supplied the photograph with its finishing touches.

Jill Kennington, a top international model in the 1960s, returned to modelling at the age of 40. My assignment was to photograph a fashion spread for a magazine, and because Jill was being featured as a 'name' and not just another model, a good, strong portrait was needed for the cover. Running quickly through the checklist: WHY? was obvious — the job was a direct assignment. WHEN? was dictated by the pre-booked session time. Although WHO? was the starting point, two factors, WHERE? and HOW? turned the basic preconceived idea into the strong image chosen by the publishers that eventually dominated the magazine's cover.

I originally imagined the picture as being shot against a plain red background (to keep it simple). The advantage of this from the graphic designer's point of view was that there would be plenty of space for logos and cover lines. Seen through the lens, however, the image lacked the impact I had anticipated. With little room to manoeuvre, I turned to possible alternatives. Three small trees standing back-lit in the corner of the studio car park provided the inspirational spark.

The session was hastily moved outdoors. I used a simple white reflector, in this instance a piece of white card, to throw light on to Jill's face under the brim of her hat. A 500mm mirror lens made the back-lit leaves appear as out-of-focus doughnut shapes and gave a strong separation between subject and background. The picture was transformed.

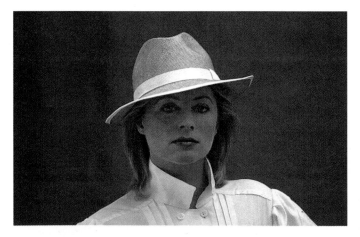

The original idea was for a plain red background, so Jill's straw hat would stand out, and soft light to lessen any skin blemishes. But the picture lacked impact and the red background was too dull.

A simple move outdoors meant I could take advantage of the bright sunlight and the trees. A reflector increased the light on the face. A mirror lens 'created' the background while adding impact to Jill's gaze.

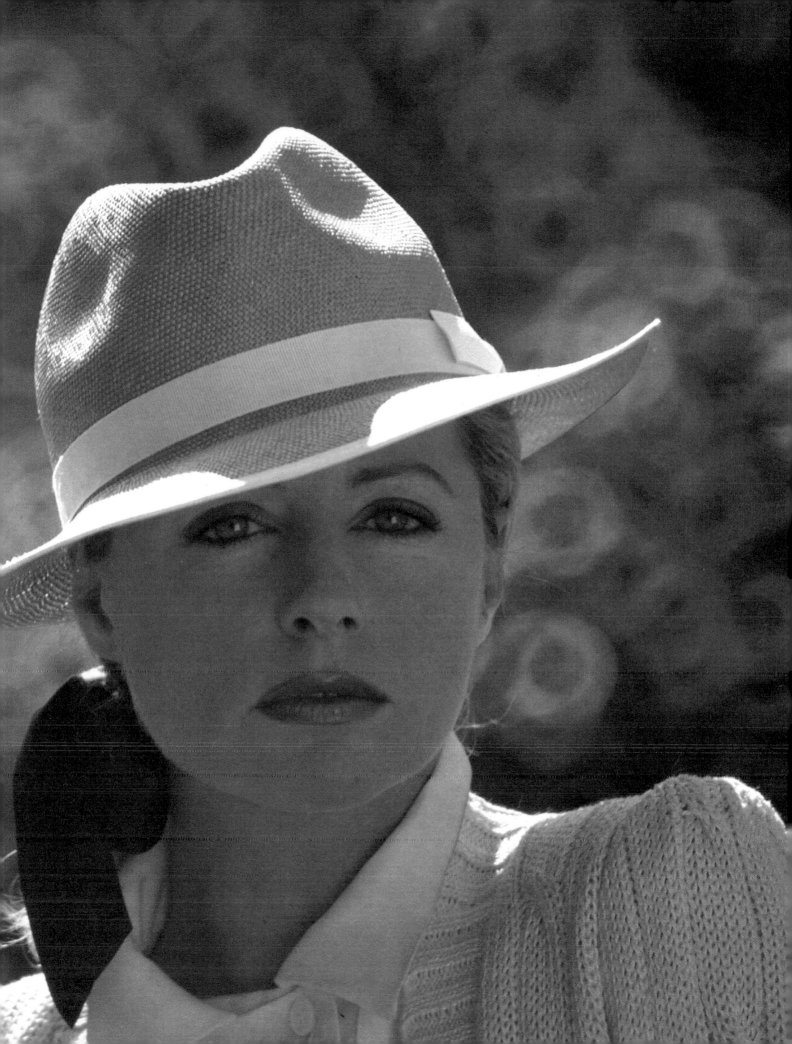

WHAT?

Large, popular events are often so busy that it is difficult to isolate the best pictures. WHAT? here is Cruft's Dog Show in London, where top dogs come to be judged. On such an occasion many photographers concentrate on the dogs and their owners. Pictures of people resembling their pets have become familiar features in newspaper and magazine coverage. It is perhaps logical to think in this direction, but the best picture at a dog show is not necessarily of a dog.

WHERE? and HOW? take a back seat in this example. WHY? is simply that this is one of the funniest pictures to come out of Cruft's for some time. It succeeds because there is not a single dog in the picture, yet it says "Dog Show" so clearly you do not need to read the caption.

The WHEN? was the obedience class, in which dogs are walked around obstacles, in this instance three seated officials. The pose and expressions of the three say, quite simply, "Sit". The timing was such that all three expressions were captured perfectly.

The photograph was taken for a newpaper and was, therefore, black and white, but it probably would not have worked half as well in colour. The stark quality of black and white focuses the humour of the situation. Many really humorous photographs are taken in black and white and appear in newspapers rather than magazines. Sadly, however, the number of black and white pictures taken by amateurs is decreasing all the time.

A predictable view of the main judging ring at Cruft's shows what you expect to see at such an event — dogs.

Sharp observation and a little thought produced a study of the human element of the show, with not a dog in sight. Technically, nothing more was required to make this picture than just a camera with a standard lens.

WHERE?

Many great pictures are the result of someone being in the right place at the right time. Opportunism is the keynote here: I could not have anticipated this picture.

WHAT? WHERE? and WHEN? were accidental. I was driving home from shopping and spotted a potential picture as early evening mist rolled over a valley at sunset. WHY? was the chance of a beautiful dusk landscape; HOW? preserved the moment.

I had a 35mm camera with a 50mm lens in the car and just two frames of Ektachrome 64 ASA left on the roll. There was no spare film, no tripod and no exposure meter. It would have been easy to admire the view from the warmth of the car and drive on home. But the chance of a good picture was not to be missed.

I abandoned rather than parked the car, speed being a necessity in the rapidly changing light. With slow colour film in the camera, a relatively long exposure was necessary. I had, therefore, to find a firm base on which to rest the camera. Fortunately there was a low, flat tree trunk by the roadside, and I held the camera down firmly on this natural tripod. I took two exposures, both guesses, but the gamble paid off.

I have passed that spot hundreds of times since, but the light has never been the same. So there is an extra lesson to be learned here: be prepared to take a chance.

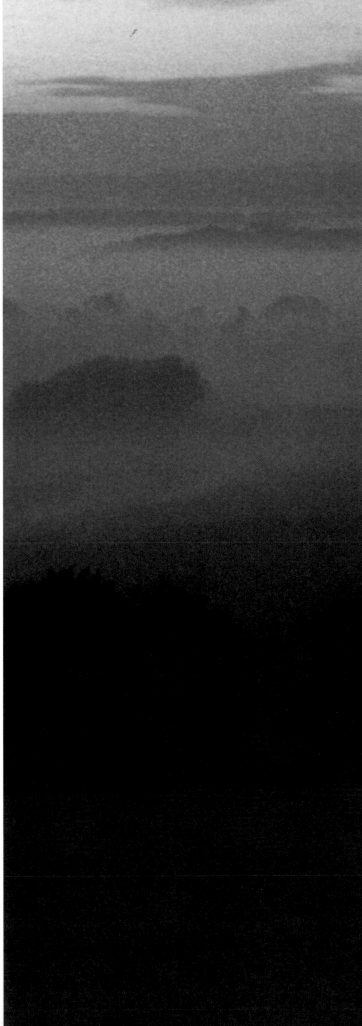

With instant improvisation a tree trunk base became a sturdy 'tripod' for a long exposure.

A long, 4-second exposure at this time of day alters the colour balance of the film, a phenomenon known as reciprocity failure. Here, it has enhanced the rich colours of the sky, so the misty valley floor contrasts well with the sunset.

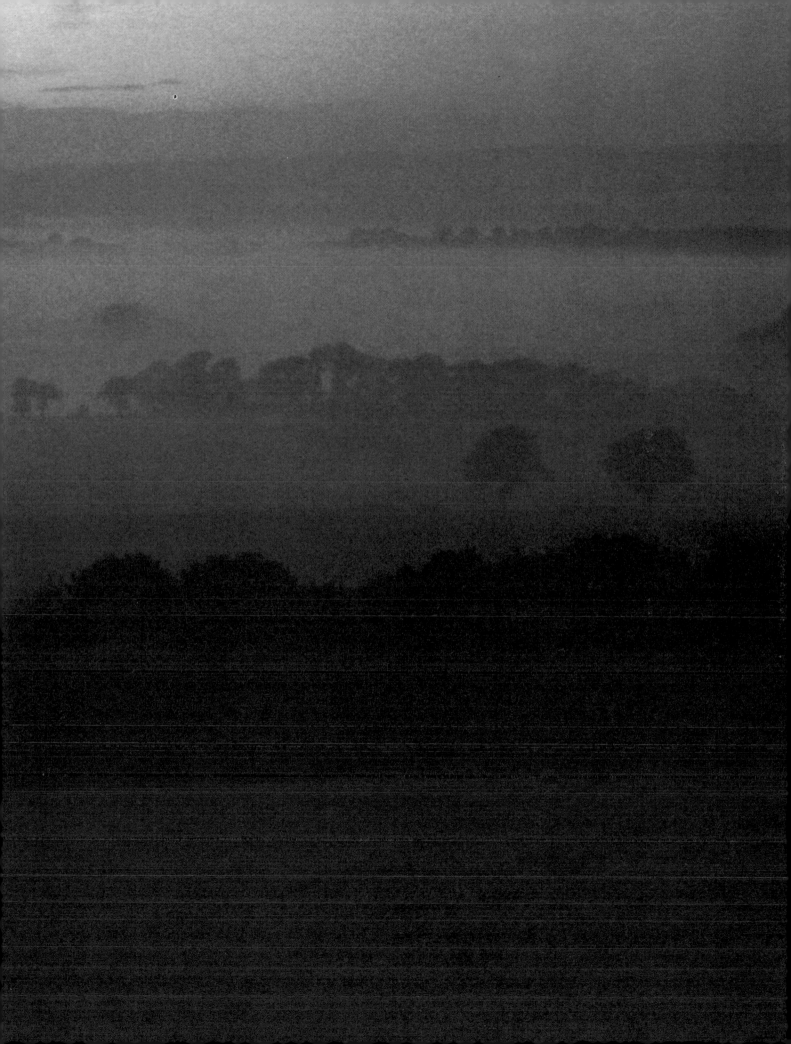

WHEN?

Time of day has a vital effect on photographs. Take, for instance, this holiday scene — a sailboard on a flat blue sea. The photographer's problem is how to make it look different from any other snapshot of the same scene. WHEN? is the key question and is closely linked with HOW?

Water can be blue, green, clear or muddy. It changes colour according to the sky — and thus the time of day — and the angle from which it is viewed. Water can also act as a mirror, and it was this thought that inspired me. The weather was too calm for an action shot, but the tranquil scene could still create impact with the right lighting.

WHERE? and WHY? were straightforward here. HOW? really became WHEN? In the late afternoon, when the sun was lower in the sky, the angle of its light was reflected off the surface of the sea like a mirror. Because I exposed for the highlights (reflections), the sky darkened and the sailboard was shown in silhouette. The flat sea suddenly came to life, providing a strong visual impact and a timeless travel photograph.

HOW? meant waiting a long time for the light to be right. So this exercise emphasizes another attribute a creative photographer must have — patience. You cannot carry it in a camera bag, but it is just as important as your equipment.

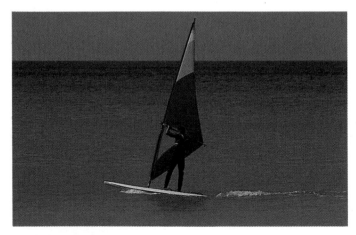

In the midday sun, this photograph is no more than a conventional snapshot. It has neither action nor atmosphere. All the details of sail and sea are visible, but the picture has little excitement.

The near-monochrome effect achieved by waiting for the light to change helps to create a picture with immediate impact. The lack of colour actually contributes to a feeling of warmth and exhilaration.

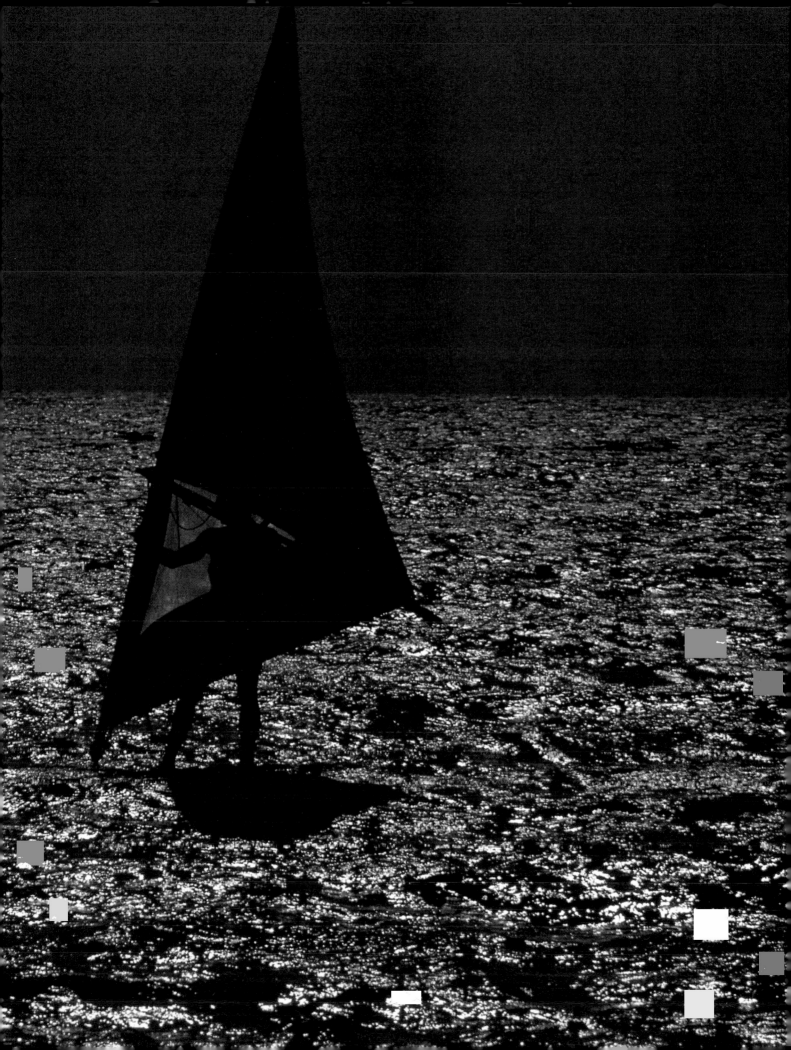

WHY?

London's Kings Road provided a light-hearted shot out of an ordinary scene, achieved by anticipation and quick thinking at short notice; this is another example of opportunism. The WHY? element was seeing an amusing (and also eminently saleable) picture in something that was about to happen. WHERE? and WHEN? were accidental; I was lucky enough to be in the right place at the right time. WHO? and WHAT?, which now seem obvious, relied at the time upon sharp observation of a developing street scene.

Two nuns were going from shop to shop collecting for charity, working their way down one side of the road. When I first spotted them they were a few doors away from a shop named *The Liberated Lady*. I had to think quickly and positively. I had no control over the situation, so I had to work out HOW? in a moment. The shop sign was important, so a square-on viewpoint seemed a good idea, not only to give the photograph a built-in caption, but also to use the shopfront as a frame for the picture. Once I had decided on the angle, WHEN? meant waiting for the nuns to arrive, enter the shop and emerge; I had time for one exposure.

The photograph has since sold well in English-speaking countries. It has the qualifications of a best seller in its simplicity and gentle humour that will, I trust, offend no one.

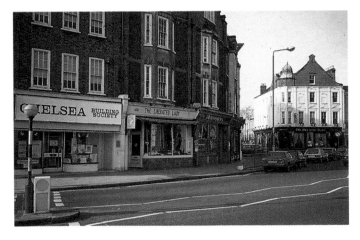

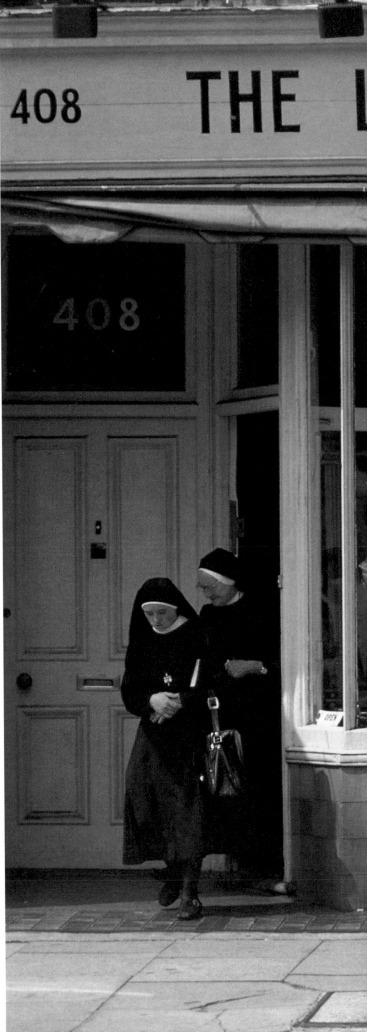

At first sight this was not a promising location for a good photograph — just an ordinary row of shops on a bend in a road that could be anywhere.

Two nuns in a humorous situation and a square-on, simply framed viewpoint turned the picture into a timeless photographic cartoon and a best seller into the bargain.

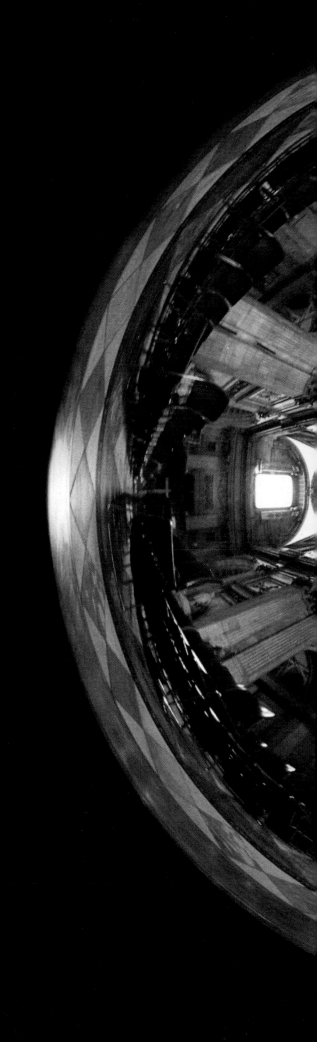

HOW?

Clear thinking may not be enough when you are faced with a difficult subject; you need a little technical assistance. This picture presented such a challenge. A large architectural interior is one of the most difficult subjects to photograph and the hardest to visualize. Imagination was also necessary here.

The human eye's normal field of sharp vision has a range of about 60°. Consequently, a visitor to St Paul's Cathedral in London finds it impossible to take in the magnificent splendour of the interior of the dome as a whole. Similarly, with a standard camera lens, only a small part of the vast dome is visible. The problem of HOW? to capture the entire structure on film was intriguing even if, eventually, the answer was logical.

My starting point was the fact that the main part of the building is circular. Why not take a circular photograph? The HOW? was, therefore, a Nikon 6mm fisheye lens. This has an extreme wide angle of view and therefore sees beyond the normal horizontal plane of the 'standard' 8mm fisheye lens.

WHEN? had to be early morning, when the cathedral was empty, otherwise the wide angle would include anybody within range, and tourists quickly accumulate from 10 a.m. onward. WHERE? was easy: there is a mark on the floor exactly under the centre of the dome. I placed the camera on this spot looking straight up in order to take advantage of the symmetry of the design. I chose a 6mm fisheye instead of the 'standard' 8mm fisheye (that is, the 220° angle of view of a 6mm lens as opposed to the 180° angle of view of an 8mm lens) so that the black and white chequered floor of the cathedral would give the picture a natural border.

Don't buy a fisheye lens: the times you will use it are too few. I hired one for this exercise. Also, if you do use one, make sure it is because the lens is the right tool for the job rather than, as in many photographs, merely a gimmick.

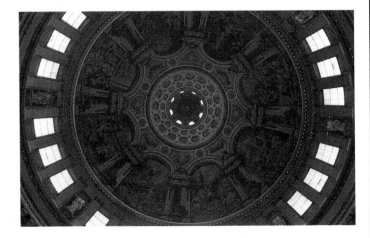

A standard 50mm lens gives a limited view of the inside of the mighty dome of St Paul's.

A sensational view is produced with a 6mm fisheye lens. I used the self-timer mechanism on the camera to give me a chance to hide behind a nearby pew. Even the most accurate exposure meter would have produced difficulties here, so I took a wide range of exposures. Since I had hired the lens, it was worth using plenty of film to get the picture right.

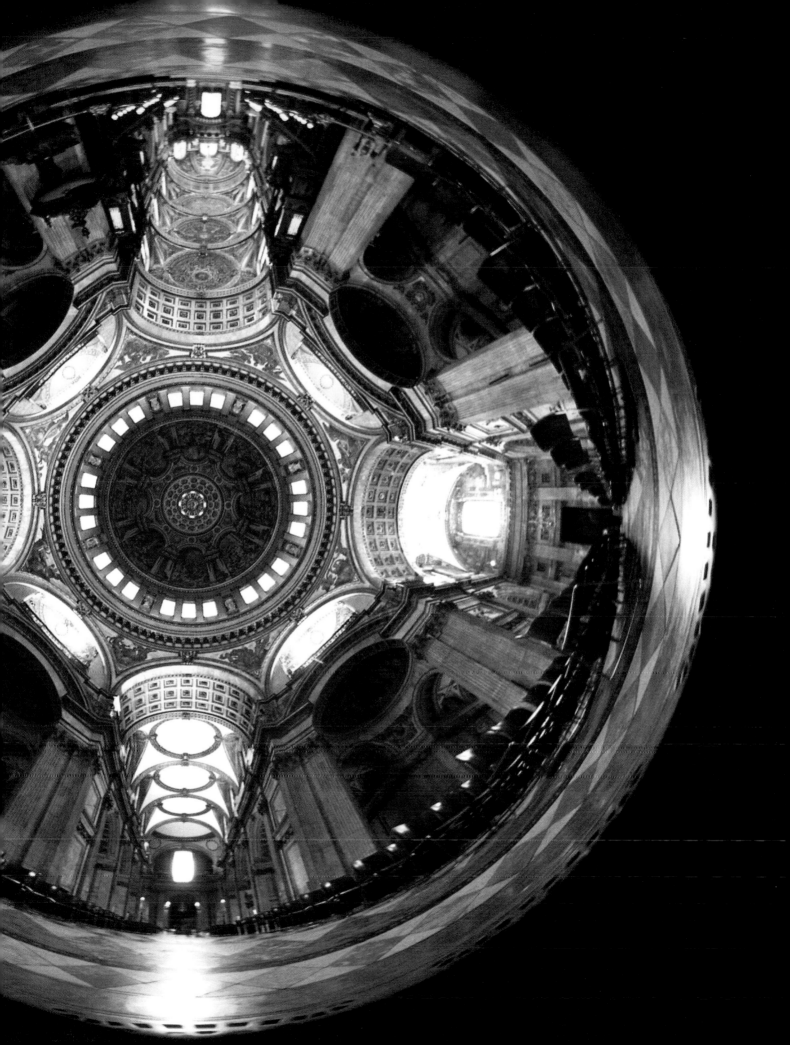

BEST SELLERS

You do not have to be a professional photographer to take a best-selling picture. By simply being in the right place at the right time, and by keeping alert to what is happening around, the amateur photographer can capture an historic moment on film that the world will clamour to see in print. Such moments are rare and it is the lucky photographer who is ready to shoot the scene.

I was fortunate enough to take such a picture in 1974, which not only had a tremendous impact in the publishing world but captured the imagination of all who saw it, and which, for me, remains a best seller more than ten years later. I was on an assignment for a national newspaper, covering the England versus France rugby football international at Twickenham in London. 'Streaking' had become a craze that year, and the first half of the match had just ended when, in front of a huge crowd that included Princess Alexandra in the royal box, Michael O'Brien set off on his now-famous streak. The Australian, who made his dash for a £10 bet (which is the exact amount he was subsequently fined), leapt completely naked from the crowd and ran across the pitch.

There were many photographers at the match, but play in the first half had ended at one end of the field and most of them were too far away to catch the latest action. I had been photographing the game from one spot and was reloading one of my cameras when the incident happened. I had a Nikkormat camera with a 200mm lens loaded with Tri-X film, and I began taking pictures as the drama unfolded.

Police rushed the streaker who, for once, was a good-looking man with a fine physique. While two policemen took an arm each, a third whipped off his helmet and tried to shield the man's private parts from the crowd's gaze. The helmet was far from stationary, however, and I remember thinking that if I did not get my timing right and capture it dead centre, the photograph would need a lot of retouching before it appeared in the next day's paper. So I concentrated on the helmet and slowed down my rate of picture-taking, waiting for the right moment.

It happened all at once. One of the good-humoured policemen said something to O'Brien, who flung his arm out, and the helmet went dead centre. I knew I had the picture, but at that moment I did not notice its other main ingredient. An outraged official was dashing up with an overcoat to shield the streaker from the Princess's view. As I released the shutter he appeared in the frame and this famous photograph was made.

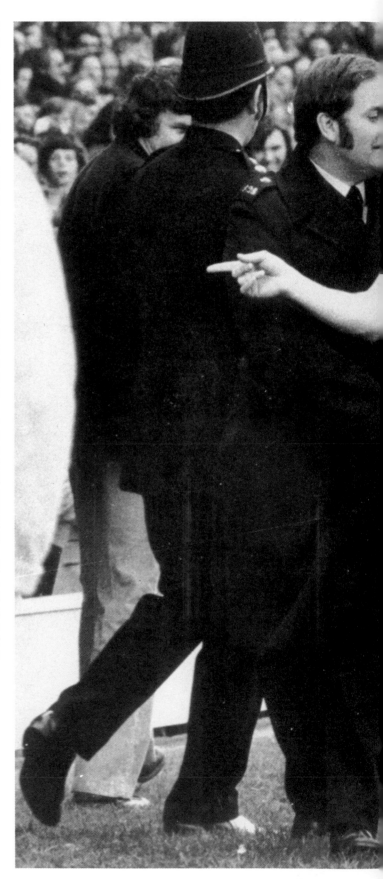

20

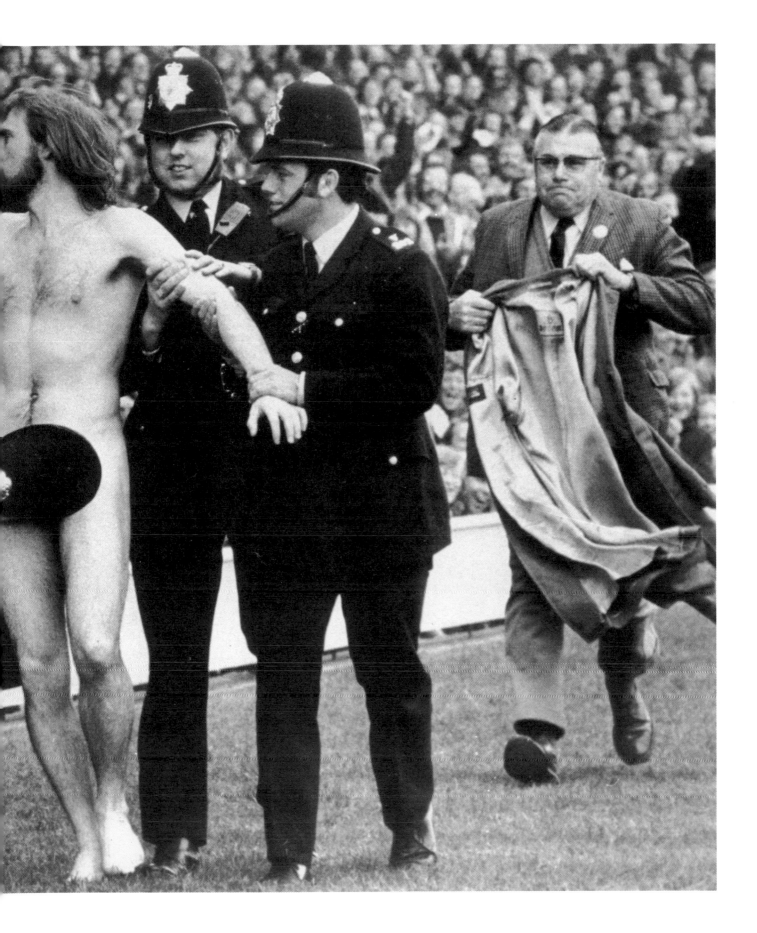

PERENNIAL FAVOURITES

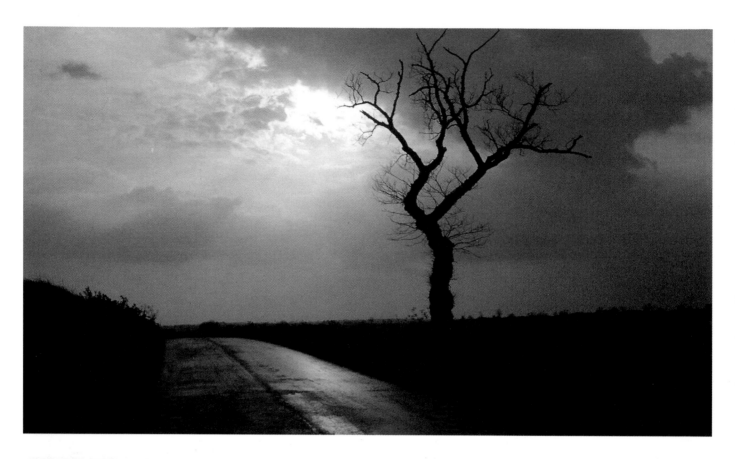

The timeless landscape is a standard best seller. This dead elm tree on a country road could be anywhere. Such a general landscape photograph has many uses as a background picture in brochures. Scenes that remain the same over the years and do not need updating because of changing fashions or skylines are always in demand. Pictures with areas of blank spaces for logos or captions are also useful to advertisers, for example.

Winter landscapes are best sellers too, perhaps because photographers' reluctance to venture out in harsh conditions means that fewer scenes such as this are taken. The seasonal uses of such photographs range from the relatively exotic, in calendars and greetings cards, to the more mundane, as in advertisements for insulation or heating systems.

The classic sunset picture is also unchanging, in this instance over Key West in Florida. It appears time and again in holiday brochures, in yachting magazines, and in literature on leisure activities and retirement. Such a picture is an even more familiar feature on calendars, postcards and as a background shot in catalogues.

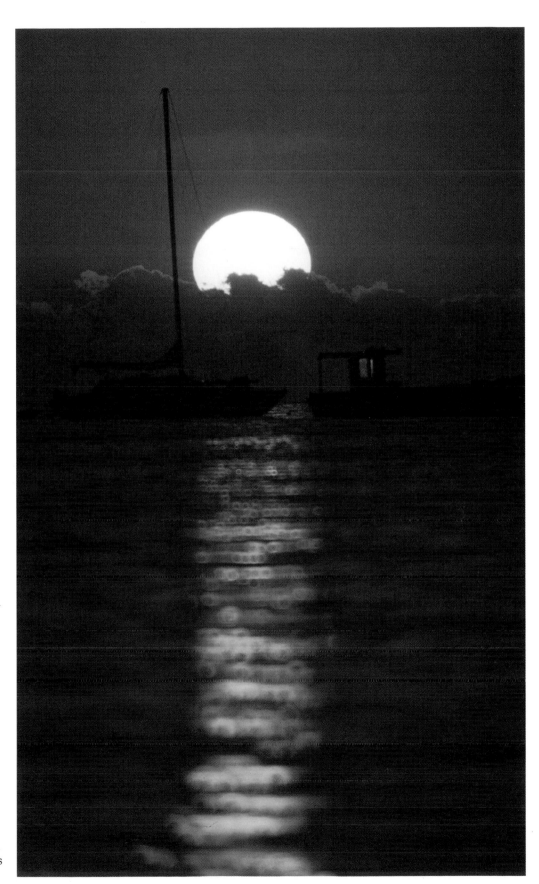

BEFORE YOU BEGIN

Facing up to the shoot begins before you leave home, not at the point of picture-taking. Clear thinking and advance planning, plus anticipation of potential problems, make it easier to take good pictures later. So, before you start taking photographs, STOP! and THINK!

WHO or WHAT am I going to photograph? WHERE am I going to do it? WHEN will I be taking pictures? HOW am I going to approach the shot? WHY is it worth taking? Then, what will the light be like; will I need a flash; what film shall I use; what problems might there be? You should answer all these questions before setting out to avoid last-minute panic and disappointment at the scene.

All good professional photographers think long and hard about an assignment, sometimes for days before a shoot. They often plan a 'safety shot' — a preconceived idea to fall back on if all else fails. Such safety measures are more often than not discarded, but they occasionally help you avoid a disastrous session.

If you own a great deal of equipment, advance planning must include decisions about lenses, filters, camera bodies and so on. But even with a basic camera and lens there are still important matters for consideration.

First is choice of film. Unless you want special effects, the basic rule is to use the slowest available film for the job. It is always tempting to choose a fast film so you can hand-hold the camera, but don't be reluctant to use slower film and a tripod or other firm base. The difference in the quality of the end result is considerable.

Second, do you use transparency, colour negative film (print film) or black and white? This is largely a matter of personal preference, but consider the result you want. For prints, negative film is better, whether colour or black and white. Negative film has a much wider exposure tolerance and latitude — that is, it gives you more room to manoeuvre — than reversal film, which produces transparencies. If you have any ideas about publishing your pictures, however, transparencies are a must. (All the colour pictures in this book are from transparencies.) Exposure has to be more accurate than with negative film, since there is no way of compensating for it in the darkroom. A transparency should be *slightly* on the heavy side (underexposed) to give good, rich reproduction. The only exception to this is with a high-key subject, such as beauty portraiture, where a slightly overexposed transparency (lighter than normal) helps keep the skin tones smooth and clean.

What other items should be on your checklist when facing up to the shoot? Apart from camera angles and lighting, think about the various 'impact' tricks at your disposal: how about a reflection or a silhouette, or even a double exposure? Do you need to hire any special equipment such as a fisheye lens? Why not photograph at night instead of during the day? There are many options to be considered before the shoot begins. So, remember to STOP! and THINK!

Excuses for unadventurous, unsuccessful photography are legion. Most common among them are: 'My camera can't take pictures like that.' What the would-be photographer means is 'I can't take pictures like that', but neither statement is necessarily true. Even the simplest of cameras is more versatile than many people think, and all photographers are capable of using their brains to work out the solution to a problem.

Many excuses are made for not taking pictures, and some sound reasonable: 'It's too dark. It's too bright. I can't take photographs into the sun. It's raining.' Here are some photographs that many people would say are impossible, not because the subject matter does not exist (see p. 172), but because the naked eye does not necessarily see a scene in the same way as a camera lens.

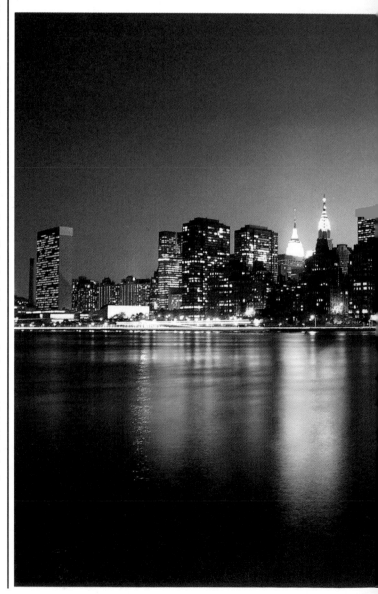

The Rock of Gibraltar was almost invisible to the naked eye when I took this picture. When asked what exposure I used, I can only reply, 'A dry martini at *f*-8!' I was sitting on the balcony of an apartment in Spain and could vaguely see the outline of Gibraltar, topped with coloured lights. With no real idea of what would happen, I set up the camera with a 500mm lens on a sturdy tripod, focused on infinity and opened the shutter. The camera was loaded with Kodachrome 64 film. I then enjoyed a leisurely drink before closing the shutter. Do not worry about exact exposure times when they are as long as this. Because you have to progress from 5 to 10 minutes to double the exposure, anything between the two will make little difference on film.

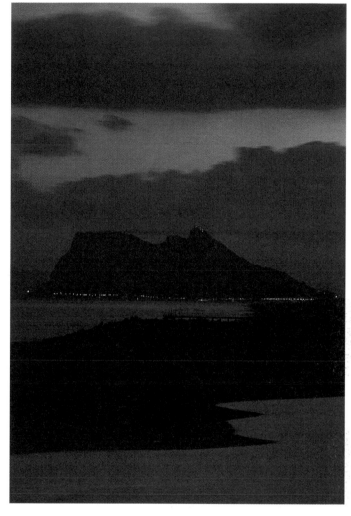

Manhattan at night does not look like this to the naked eye, which is swamped by the bright lights. The eye cannot discern colour in the sky, or in the shadows. A long exposure of colour film at night can enrich the hues both of sky and reflections due to reciprocity failure. The exposure for this kind of subject is difficult, even with a meter, and I advise you to try several combinations of shutter speed and aperture setting to make sure you get it right. In this instance, I held the camera firmly on a low wall and made an exposure of about 20 seconds. The river's flow turned the reflections into coloured blurs. Still water would have given a clear mirror image, which could have been overpowering.

KEEPING AN OPEN MIND/2

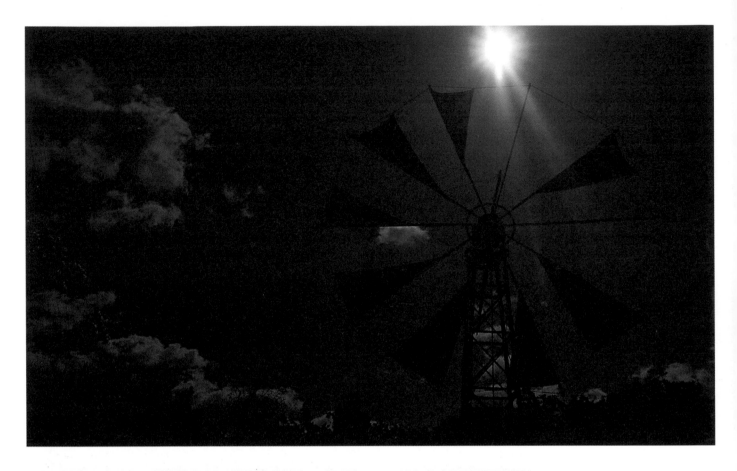

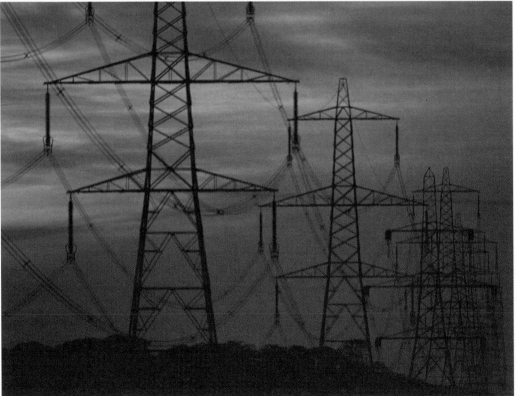

You *can* take pictures into the sun. This photograph of a Cretan windmill even has the sun in the picture. It was a broken-down old mill that was unimpressive when viewed from the other side with the sun shining on it. But, because I exposed for the sun, the windmill is silhouetted against the sun itself, and an ordinary subject becomes picturesque, conveying a feeling of Mediterranean warmth.

Electricity pylons are photogenic. A rich, orange sunset silhouettes the line of towers and gives the picture a strong graphic quality. A normally mundane subject was thus transformed. This photograph has sold well as a background for advertisements and for annual reports in the business world.

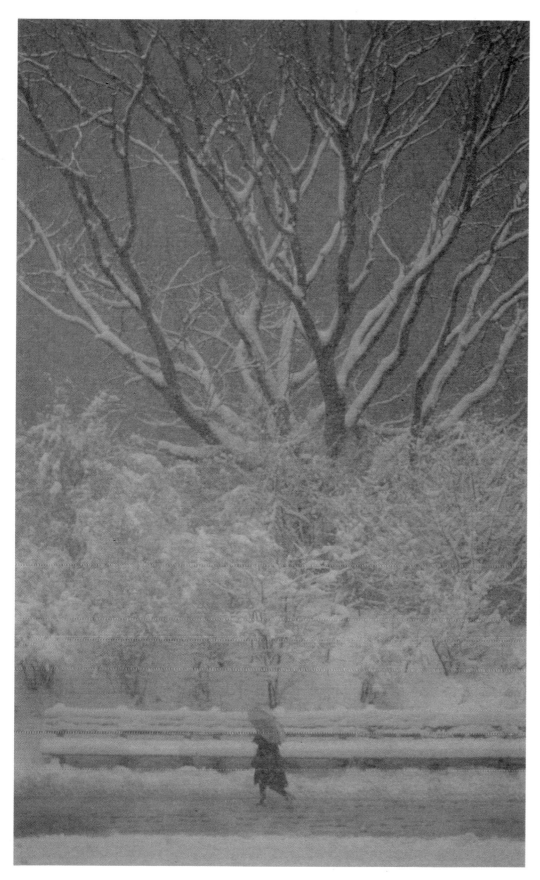

Do not put your camera away in winter with the excuse that there is not enough light. Cold, grey days can provide pictures, too, especially if there is snow on the ground. This photograph was taken without ever leaving the warmth of home — from a window overlooking Central Park in New York. A figure in a landscape gives an idea of scale and adds depth to an otherwise ordinary scene.

TAKE SIX THINKING PHOTOGRAPHERS

Everybody sees pictures differently, and individual photographers approach the same assignment in a variety of ways. The following 16 pages show the vastly different work of six professional photographers faced with the same basic situation.

The six photographers, each a specialist in his or her own field — photojournalism, landscapes, fashion and still-life — were asked to photograph a girl in a bare room. They were given the same equipment, the same model (in the same clothes), the same room, and they all worked on the same day. Each was given one hour to produce a photograph or a series of photographs. The choice of film was left to the individual, but, apart from that and the sun moving around the building during the day, the conditions were the same for all six.

The model, Vicki Michelle, is an actress who has had modelling experience. She wore jeans, jacket, T-shirt and high-heeled shoes to the session, and the photographers were allowed to vary her clothes, make-up and hair. The room was on the top floor of a warehouse, bare apart from a step-ladder and some old curtains at the windows. There were windows down each side of the room, giving soft cross-lighting, and a bare brick wall to the rear. The floor was laid with pine boards.

Each photographer was given a 35mm SLR, a 55mm lens, a tripod, a flash with a long sync cord, and a piece of gelatine to place over the flash to simulate a tungsten light source.

Their reactions to the situation varied. Some chose to ignore the room and concentrate on the girl, while others made full use of the space. The job demanded quick, clear thinking without the aid of fancy props. It called for good communication between the photographer and model, as necessary a requirement as the equipment.

From the model's point of view, it was an unusual exercise: to be photographed by six different people, one after the other without a break. It was a totally new experience for Vicki, and her reactions, as well as each photographer's thoughts on his or her work, are expressed on the following pages.

The basic equipment was a Nikon FM2 camera with a 55mm f-2.8 lens. The camera has a built-in exposure meter and a double-exposure capability. The electronic flash was a Metz CT-4, which automatically gives the correct exposure.

The long sync cord enabled the flash to be placed well away from the camera if necessary. The four-extension tripod was a sturdy Gizzo with a pan and tilt head. The step-ladder was available for use by photographer or model.

THE AUTHOR

Ian Bradshaw, author of *The Thinking Photographer*, thought up the idea of this assignment and specified the conditions. Ian was the first of the six photographers to do the assignment. This is just one of the many thoughtful and inspirational notions Ian has brought to photography through this book. Ian's experience is wide, but his speciality is reportage photography.

'I like to work fast. This probably stems from years as a news photographer, but I find that if I keep moving it helps to relax my subjects and gives them no time to feel self-conscious. The first thing that struck me when I saw the room was the size of the windows. I am conscious of the fall of light and design in photographs; I like clean, simple and direct pictures. It seemed to me that the most natural thing to do was to use the strong frame of the window recess, just as in an old painting. I put Vicki into the frame, where she was perfectly balanced. The picture was strongly graphic, with the black window-frames within the main picture helping to create a symmetrical pattern behind the model. I wanted a slightly aggressive pose and I angled the arms and legs to fill the frame. I used 1000 ASA 3M film.'

Large areas of black, offset by the window, create a strong design that focuses the viewer's attention on the subject.

The strong, warm afternoon sun was used here. The model turned so that the light hit the front of her body. Her direct gaze is emphasized by the face being turned just enough to catch the light.

There is a good use of space, which adds to the atmosphere. The grainy quality of the film adds a feeling of mystery, and the side-lighting gives the picture a lonely quality.

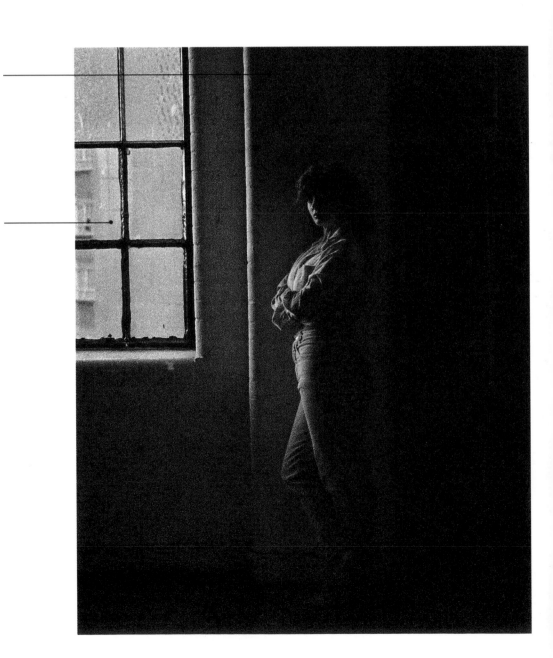

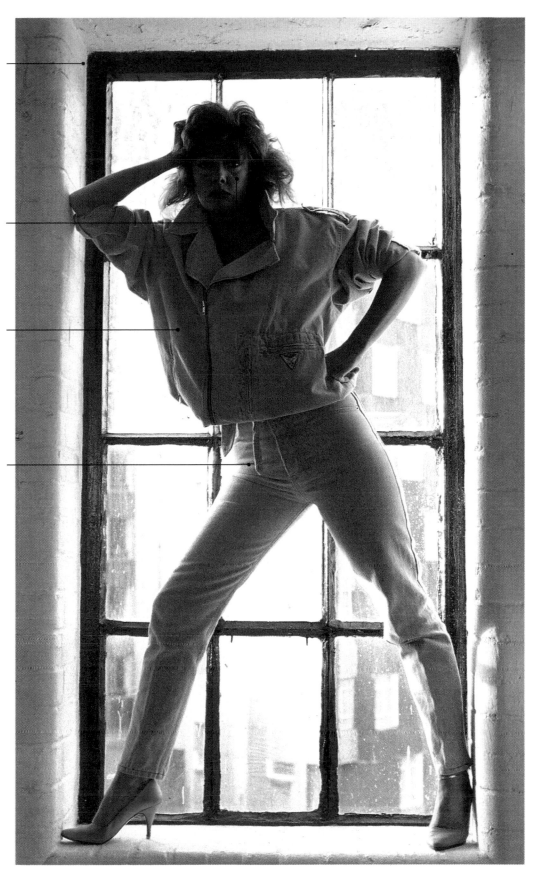

Framing within a frame was made possible by the window recess with the black window-frame inside it. This graphic effect draws the eye in to the main subject — the model.

A warm patch of sunlight on the model's left cheek was used for an exposure reading. The grainy quality of the superfast film was used to add impact.

An aggressive stance not only helped balance the picture but gave it a strong graphic quality, with a clear separation between the arms and body. The model's direct gaze into the lens creates the feeling of challenge.

The angle of view was just below waist level to give height to the model, but it was not low enough to distort the vertical frame of the picture. This angle also makes the legs look longer.

Vicki's view: 'Ian communicates clearly. He went straight to the window and explained what he wanted. I had to stretch my legs and arm to fill the space, but the picture is relaxed. We shot this photograph in the first five minutes of the session.'

THE LANDSCAPE PHOTOGRAPHER

Patrick Thurston specializes in landscapes and travel photography. He works mainly outdoors and seldom uses artificial light, natural light being most important in his work. He often spends days in a camper waiting for the perfect dawn or sunset. His pictures have appeared in books and major travel journals around the world.

'I had not been in a studio for years and found this exercise a great challenge. I aimed for simplicity and a strong image. The shoes were a happy accident. In a casual situation with casual clothes, the high heels seemed too formal to me. Vicki took off her shoes and was on the point of discarding them altogether when I had the idea of using them as a frame. I asked Vicki to put her hair up to reveal more of her face and to give a smoother line. I like to be mobile, so I did not use the tripod, preferring the floor as a solid base for my camera. The film was Fuji 400 ASA to give me the depth of field I needed. I was also aware of a lot of blue in the picture and positioned the model near the wall to take advantage of the warmth of the bricks.'

The lines of the window help lead the eye to the model's face. The camera was positioned near the glass, and the strong but soft light through frosted glass emphasizes her facial features. The swept-up hair shows off the cheekbones. A creative use of space positioned the model well to the left in the frame. Light falling on the wall throws the head into strong relief.

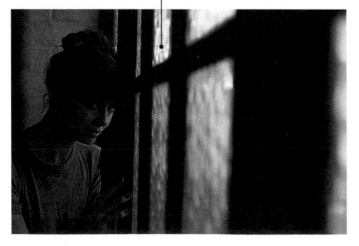

The shoes make an unusual frame and were positioned to focus the viewer's eye inward and toward the model. Using the shoes in this way also adds depth.

The brick wall as a background adds warmth to what would otherwise be an extremely cold, blue photograph. The warm shade of the bricks reduce the dominance of the blue shoes.

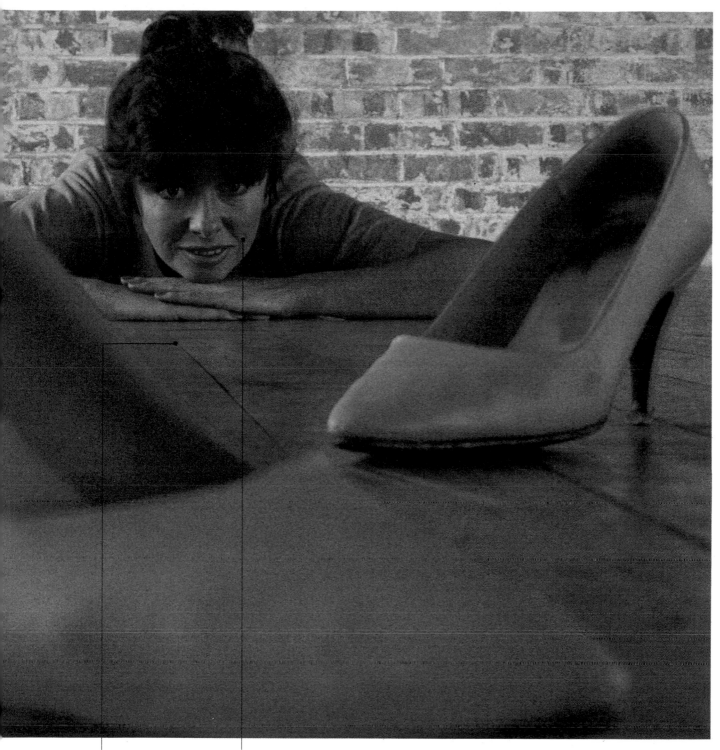

A good use of perspective leads the eye immediately to the model's face via shoes and floorboards.

Model and lens are at the same level, emphasizing her direct eye contact with the camera. Her pose is relaxed with head on hands. The hairstyle draws attention to her cheekbones.

Vicki's view: 'Patrick adapted quickly to what was obviously an unusual environment for him. He found the combination of jeans and high heels incompatible, but he seized the opportunity of using the shoes in an unusual way. They became the principal ingredient of the picture even though I was not wearing them. Patrick was a good communicator and it was easy for me to know what he wanted in the shot.'

THE STILL-LIFE PHOTOGRAPHER

Julian Nieman is a commercial and advertising photographer who specializes in interiors and still-life. Most of his work is carefully thought out in advance and just as carefully lit before he starts. Although much of his work is done on 35mm, he often uses large-format cameras backed up with big lighting setups.

'When I was asked to do this assignment I tried to keep an open mind and not have any preconceived ideas. I wanted the room to inspire me. At the back of my mind I was conscious of windows and silhouettes, and when I saw the patterns of light in the warehouse I turned to black and white rather than to colour. One of the things I was acutely aware of was the line of the curtains and the way the light fell, which is why I did not want the human figure to dominate. I felt it unnecessary to show Vicki's face; I wanted every viewer to imagine their own person in that space. I used Ilford XP1 film.'

Design is the key here. The angles of the roof girders mirror the lines of the curtains on the floor. The picture makes good use of light-fall from the windows and is well balanced, with a strong focal point. This time we see the model's face.

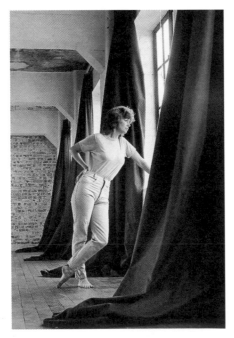

Texture is an important element in this picture, with the floor and the wall taking up a large part of the frame. The smooth floor leads to the rough-textured wall, providing a strong space full of patterns.

The use of space here creates the mood. The picture is simple, yet strongly designed, to keep the viewer's attention. There is a haunting quality about it.

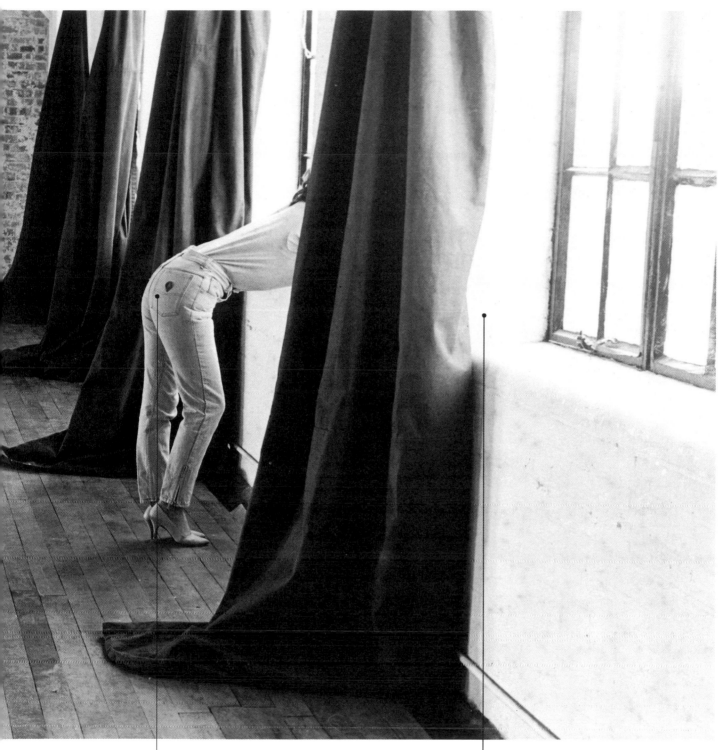

The model's shape complements the line of the curtains, forming a still-life with a strong design. The pose is relaxed. The deliberate cutting-off of the head provokes the viewer into speculating who she may be and adds an air of mystery.

Soft light flaring in from the windows gives a bright, lively feel to the picture, accentuating the dark symmetrical drapes.

Vicki's view: 'Julian works much more slowly than the others and is obviously a great thinker. He communicates well, and I was able to relax into the interior landscape he was creating.'

THE PORTRAIT PHOTOGRAPHER

Jennifer Beeston is an editorial photographer working mainly for magazines. She has developed a simple, straightforward style in portraiture and likes to observe people rather than to pose them. She works mainly with 35mm cameras and available light wherever possible.

'I did not want a posed photograph, so I asked Vicki to take off her make-up, mess up her hair and wear the T-shirt and jeans with no shoes. I wanted a casual approach to get the picture to look natural and intimate, as if I had happened to find Vicki in reflective mood and unaware of the photographer. I tried to imagine that we were in Vicki's apartment, not a large, impersonal warehouse. We developed that atmosphere by moving around until I found a place that seemed suitable. Maybe I should have made more of the room, but it did not seem relevant at the time. I used Fuji 100 ASA film.'

A pensive mood is caught in this beautiful, relaxed study. There is a good modelling on the face from the soft side-light, and the floor is thrown out of focus so that it does not detract from the subject.

No make-up and tousled hair both add to the general effect of observed informality.

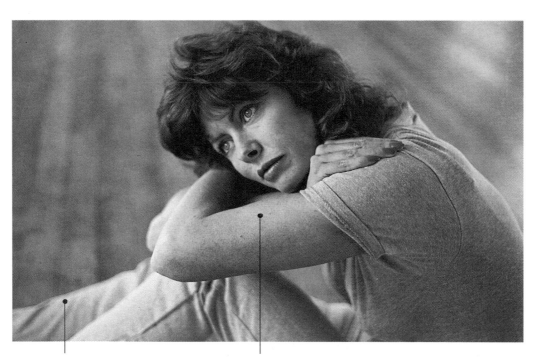

With the out-of-focus wall as a backdrop, the stark warehouse does not intrude on the picture, although the colour of the wall adds warmth. The 'at home' feeling has been enhanced by reducing the background to a minimum.

The model's character emerges best with a simple approach. She is not overshadowed by her surroundings. The mood is reflective, the natural light from the windows soft and warm.

The relaxed, natural pose is the key to the mood of the picture. By both photographer and model thinking of the room as a home, rather than a warehouse, the mood was enhanced.

Vicki's crossed arms, hugging herself, add a comfortable warmth and counteract the barren atmosphere of the warehouse.

Vicki's view: 'I found this session the most difficult of all. The result is beautiful and relaxed, but at first Jennifer's approach threw me off balance. I had to be natural and ignore the lens, which does not come easy to someone trained to be acutely aware of a camera. I had to force myself not to pose and I had to concentrate hard to relax.'

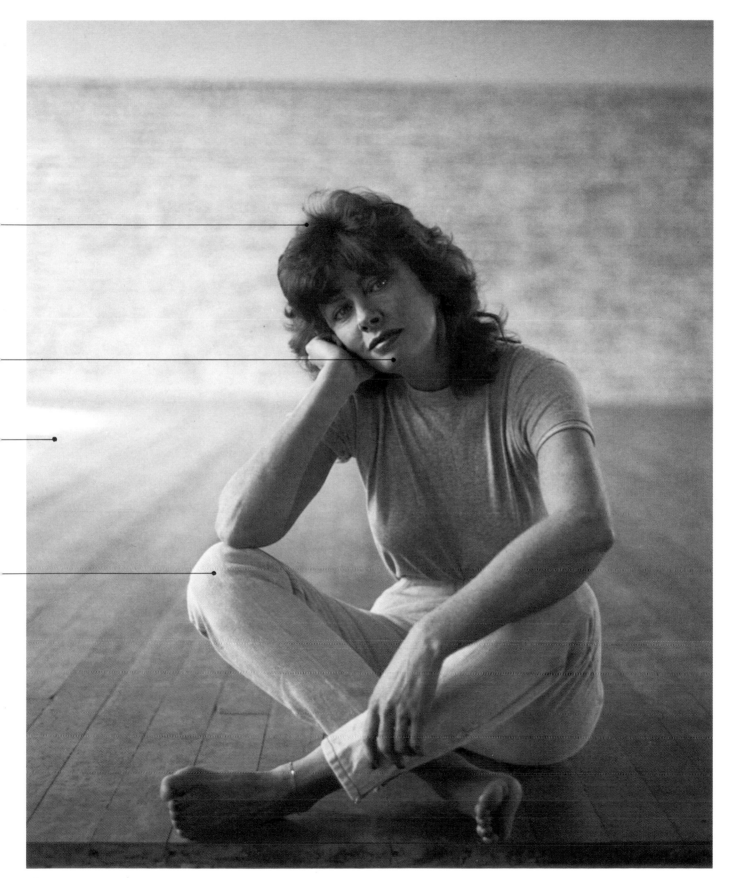

THE REPORTAGE PHOTOGRAPHER

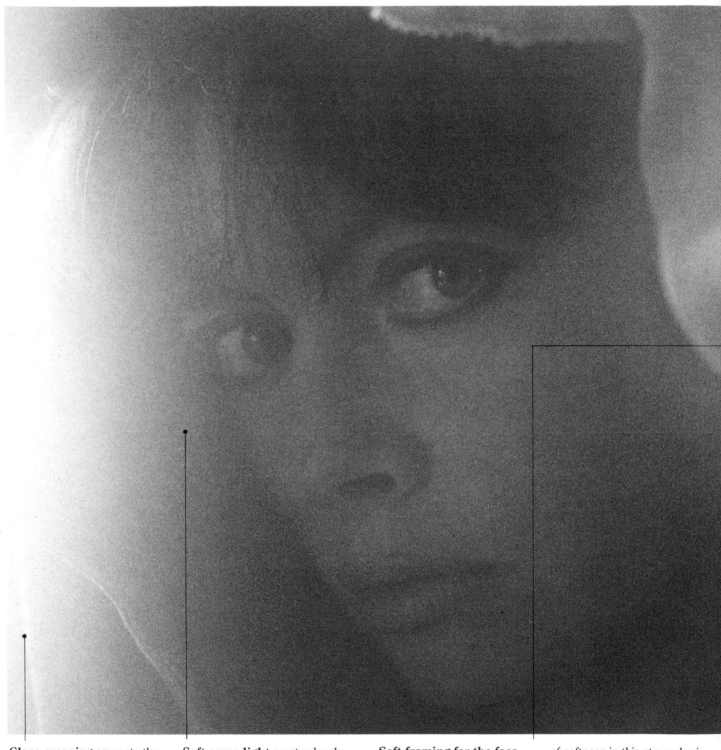

Close cropping prevents the room intruding. This intimate moment could have been captured anywhere, at any time.

Soft cross-light creates lovely modelling on the face and adds to the tranquillity, while at the same time giving just a hint of mystery.

Soft framing for the face was created by Vicki holding up her denim jacket. A soft-focus effect was produced by breathing on the lens and shooting as the mist cleared. The slightly grainy quality of the fast film adds to the feeling of softness in this atmospheric photograph. The model's direct gaze into the camera creates impact.

Martyn Goddard is a fast-working reportage photographer whose illustrative work is in constant demand by magazines. He also does much work for the record industry and specializes in car photography. His pictures cover the whole spectrum of photojournalism.

'This was a limiting situation, and because of that I felt that the picture should be quick and direct. It was immediately obvious that Vicki was an actress, and I felt that I should take advantage of that. So, with acting the keyword for me here, I went for a picture with a strong frame. Initially I ignored the room, using the model's arms to create a frame for her face. There was a beautiful, soft cross-light, and I asked her to hold up the blue denim jacket to make a frame for the picture. I used Fuji 400 ASA film to take advantage of the slightly grainy quality and worked with the lens aperture wide open to minimize the depth of field.'

A black and white image was the original idea behind this shot. The model threw her head from side to side during a long, one-second exposure so the hair had soft edges. A flash fired during the exposure 'froze' the face. The wall in the background creates the 'madonna' effect of this stark portrait by contrasting the rough texture of the bricks with the bleached-out skin tones.

Vicki's view: 'Working with Martyn was similar to working with Ian Bradshaw. He was fast, positive and decided right away what he wanted to do; another good communicator who explained the picture he wanted. It was a real strain on my arms holding them over my head, but knowing what he was trying to achieve made it easier.'

39

THE ADVERTISING PHOTOGRAPHER

Nigel Macintyre works in advertising and is at home with large-format cameras. Most of his work is shot on 10 in × 8 in large format cameras. He does not even own a 35mm camera or an exposure meter; he uses Polaroids to work out his exposure readings. He uses large amounts of electronic flash, and often has two or three assistants.

'This, for me, was totally out of the ordinary. The smallest camera that I normally work with is a 4 × 5-inch view camera. I do a lot of multi-exposure work in my advertising assignments, and I like to play tricks with the camera and the light. I seldom just shoot. My pictures are usually built up through a series of Polaroid test shots until I get what I want. In this instance I used the 35mm camera like a plate camera, blacking out the room as much as possible and opening the shutter while the model moved around. I "painted" her with light, following her and firing the flash on an open setting to create a ghostly sense of movement within the frame. I like to build up a story on one frame of film, leaving the viewer to interpret it as he or she wants to. The film was Ektachrome 64 ASA.'

The story builds as the model walks from left to right with the photographer trailing her, firing the flash at her back. The camera shutter was open all the time.

Moving the light, as well as the model and the camera, is a technique that helps create a mood or effect.

As the model turned to the camera at the end of her walk, the flash was fired to illuminate her face. Another print-through, this time of the pillar, adds to the ghostly feeling.

Vicki's view: 'I found this session difficult to understand, since it obviously involved a technical trick, and I could not visualize the finished picture. However, Nigel directed me clearly and I imagined that I was making a film. I therefore did as I was told without ever fully knowing what mood to generate. I found it hard to feel a part of this picture.'

The curtains were whisked aside at the end of the exposure to add print-through and create a further air of mystery within this ghostly image.

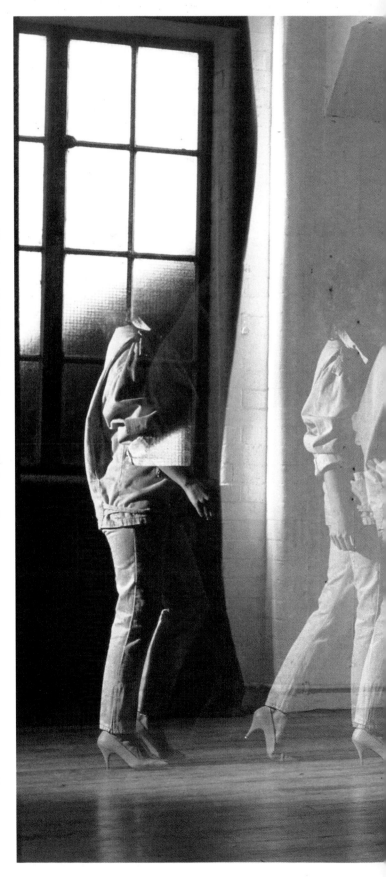

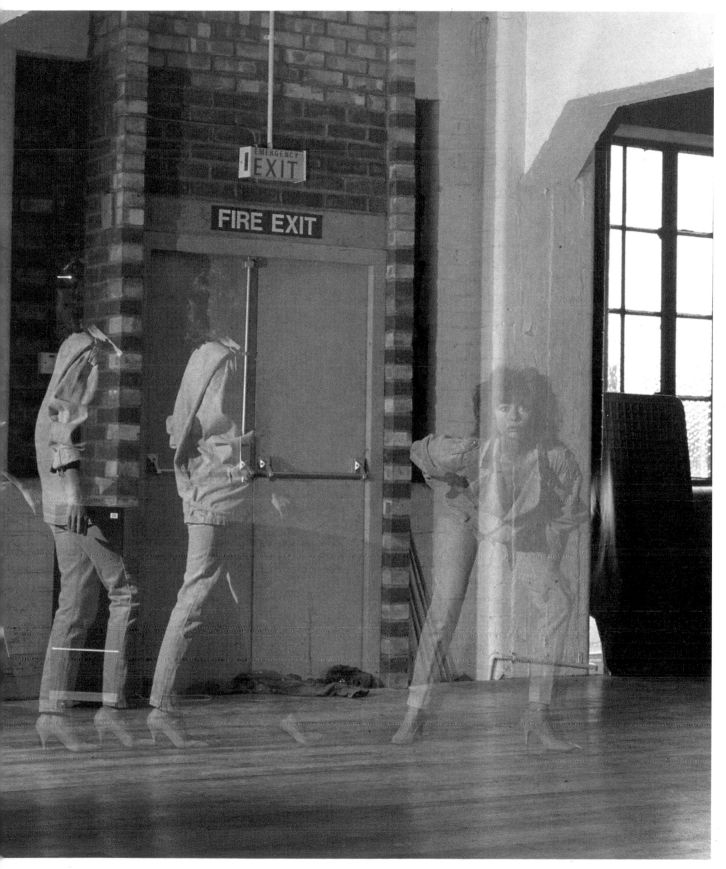

THE BEST OF THE REST

Many images were produced by the photographers during the six hours. Several that were not chosen by them as best examples nevertheless illustrate the immense range of possibilities for picture-taking when it is tackled by thinking photographers. A further selection is reproduced here.

When asked at the end of the day for her overriding impressions of the six, Vicki Michelle was quite clear on three points: 'They all think clearly about what they are doing. The technical side seems so much second nature to them that I was often unaware of the camera being present at all. Also, they are all good communicators. They can express themselves clearly and positively, and they are good at making people relax. Finally, they seemed — except for Nigel — to want to simplify things all the time, rather than depend on technical trickery. I think the secret of their art lay in this approach.'

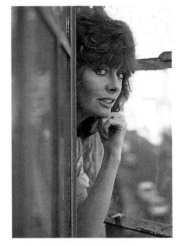

Opening a window and leaning out, Ian Bradshaw pictured Vicki from the outside as she peered out from an adjoining window, proving that working within a room is no great restriction on a thinking photographer. This picture utilized the maximum amount of daylight. The faint reflection of the model's face in the glass adds balance to the portrait.

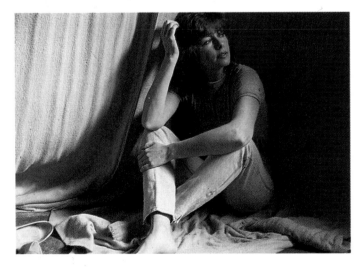

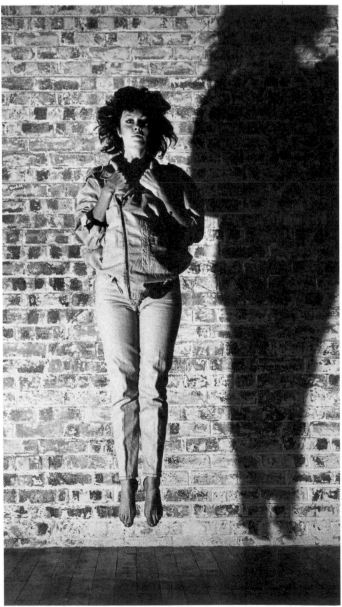

A warm cosy feeling was added to the bare room by the curtains. Jennifer Beeston found a quiet corner and used the soft window light, together with a relaxed pose, to convey a feeling of a home rather than an empty room.

Creativity through movement was the aim here as Martyn Goddard asked Vicki to jump against the rough brick wall. Black and white film, and the use of simple flash to the left of the camera created a different 'frozen' effect. The strong shadow in the picture adds impact.

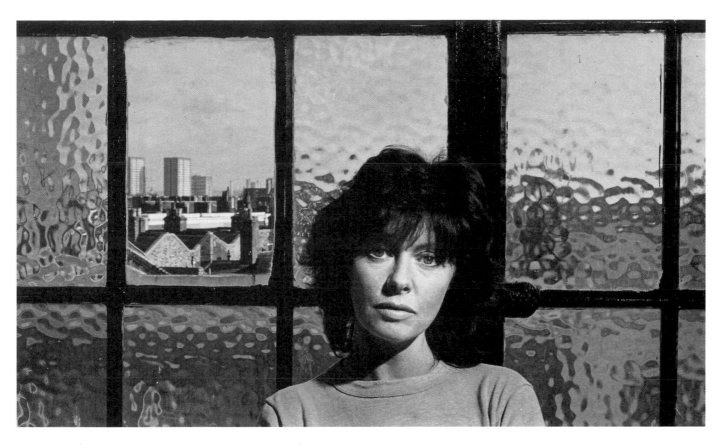

In his wanderings around the warehouse room Julian Nieman came across a piece of clear glass in the middle of a window of frosted panes. Using black and white film and stopping the lens down to get a large depth of field, he held the flash to one side of the camera. The overall effect was to convey the industrial nature of the building in a well-composed, direct portrait.

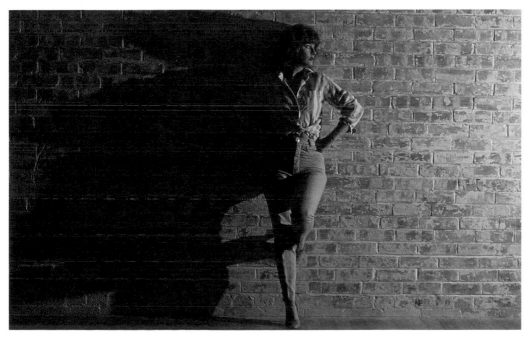

The use of shadow. Ian Bradshaw 'kills' all daylight in the room and creates a night 'alley' feel with a simple, strong side-light. The flash was placed on the step-ladder to the left of the model with an 85B gelatine filter over it to give the impression of a light from a light bulb. The model was positioned against the wall, and the giant shadow she cast helped give the impression of night-time. The sharp angle of the light gives heavy texture and contrast to the picture.

PORTRAITURE

When taking pictures of people, technique is often secondary to a vitally important attribute that the photographer must have — the ability to communicate and get on well with his subjects. Good communication always shows itself in a portrait, especially in the subject's eyes. Whether you are taking pictures of a formal, posed situation or an informal gathering of family and friends, the same rule applies.

There are different ways of achieving this rapport. I always talk a lot to my subjects and, more important, I get them to talk to me and I listen to what they have to say. I ask them questions about themselves, preferably not the sort to which they can give monosyllabic answers! Other photographers do not talk to their subjects and rely on observing the moment when they 'see' the picture. This can make the subject feel uneasy.

The problems facing the portrait photographer are varied. If you are taking pictures of your family, the location may be uninspiring; if your subject is a well-known personality, the difficulty will be getting enough of his or her time; and, whatever the circumstances, your subject may endure rather than enjoy being photographed. People frequently say that they photograph badly. This is often because they do not let the photographer establish a good relationship with them.

The formal approach to portraiture is demonstrated first in two pictures of British aristocrats. The picture opposite — of Maria Walsh, secretary of the West Carberry Hunt in Ireland — is also carefully posed.

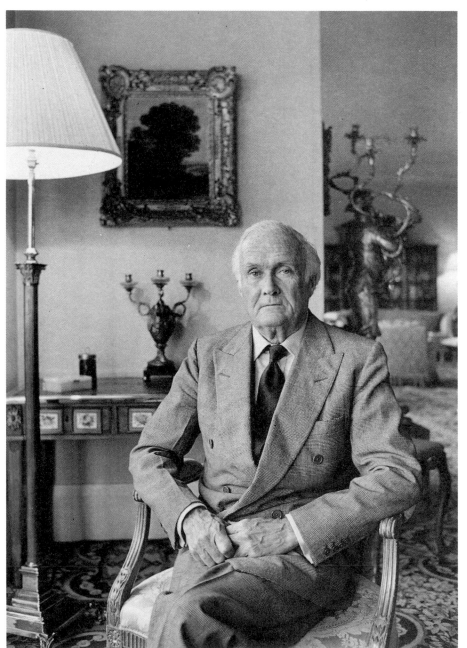

The Duke of Richmond is perfectly at ease standing by the window of his London home. The archway strengthens the framing of the picture as well as adding to the composition. Daylight was the only light necessary. Sitting or leaning poses help your subjects relax.

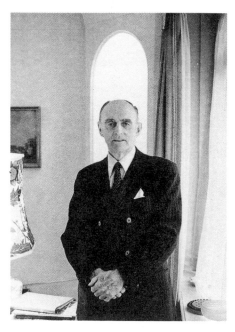

The Duke of Rutland's lifestyle is obvious in this portrait taken in his stately home, Belvoir Castle. The strong composition adds impact. The size of the drawing-room to the right is balanced by the lamp and painting on the left. Care was taken that the subject's head did not overlap the corner of the alcove or the painting. Soft window light was the only illumination.

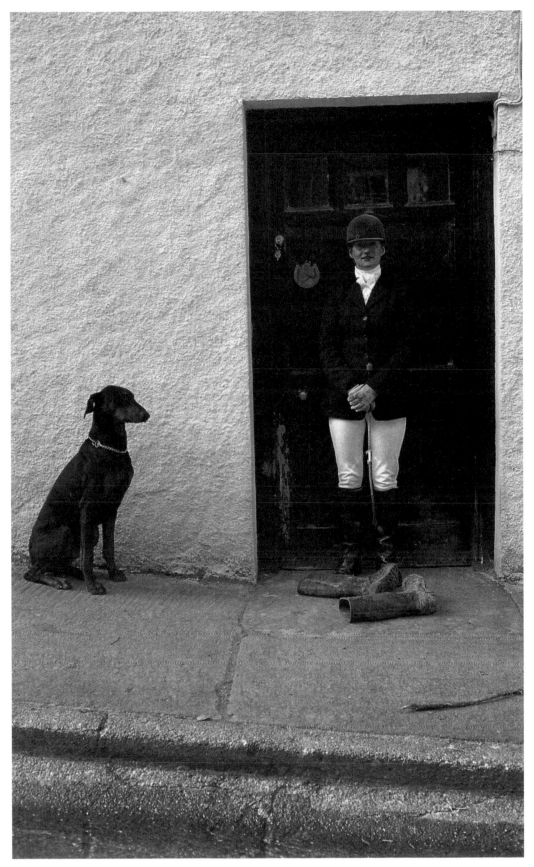

The black door frames the figure within the main frame of the picture. Normally, black clothes against a black door would not be a good idea, but here the image is held together by the patches of white. The lack of separation between body and door adds a slight sense of mystery.

The subject need not dominate the portrait for a successful result to be achieved. Maria is, however, the main ingredient, and several devices lead the eye to her. These include the dark shape of the doorway and the slope of the road. An additional bonus was the discarded pair of boots.

A black dog happened to sit down in exactly the right spot to balance all the other ingredients of this picture. He is an almost incongruous figure, but his ears, flared against the wall as he growled at the photographer, add an interesting shape.

A FRAME WITHIN A FRAME

As with portraits of old, the framing of a photograph can enhance or ruin a picture. The use of a natural frame within the main frame can make ordinary picture much more interesting. Below is another method of framing that transforms a standard portrait into a picture of outstanding beauty.

The starting point was a shot of actress Fiona Fullerton for a weekend magazine. Fiona had originally risen to fame in the film version of *Alice's Adventures in Wonderland,* and was soon to appear in a new James Bond film. The problem was how best to illustrate the transition of her image from 'child star' to sophisticated movie actress within the confines of both the studio and Fiona's hectic schedule. An interesting thought process in the photographer's mind produced the end result. 'I was reminded of the other Alice, who steps *Through the Looking Glass* into another world. I used an antique mirror as a frame within the frame and clearly portrayed the actress's new image.'

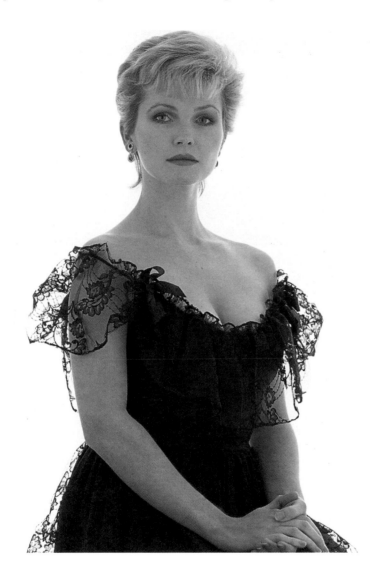

The finished picture, with the *Through the Looking Glass* effect, was used on the cover of the magazine. The mirror draws the eye into the face and adds impact to a previously ordinary portrait.

The frame was created by placing the mirror where Fiona had been sitting. Light was directed on to the studio wall behind the mirror and this reflected back on to Fiona's face in her new position facing away from the camera.

The mirror was angled so that the camera could see Fiona through the mirror with the image centred. A white background was positioned behind her so that the studio lights and equipment were invisible to the viewer.

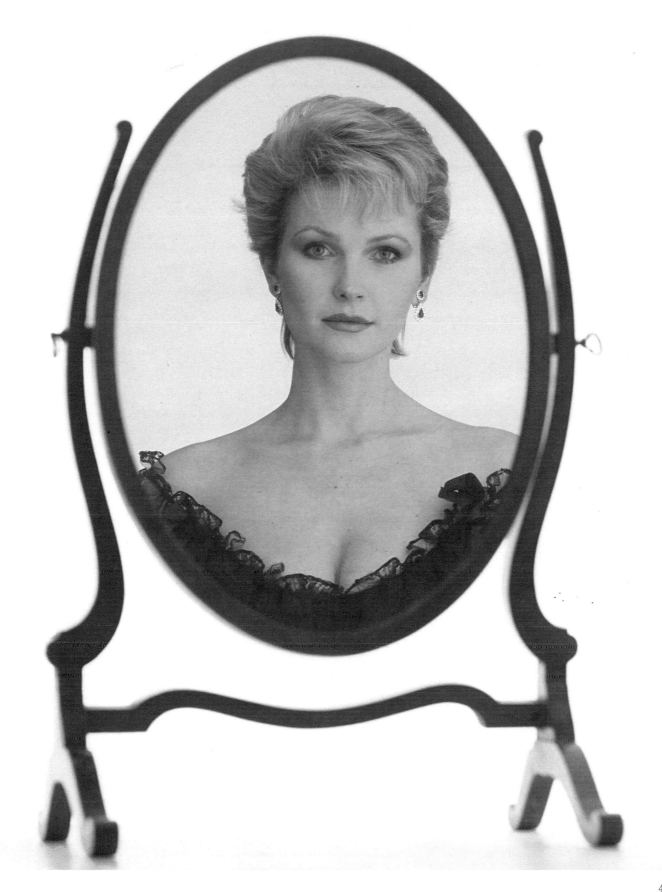

THE FAMOUS FACE

Photographing the famous is not all fun. The chief problem for the photographer is to fit into the busy schedule of the personality or star. This example, of photographing a well-known actress, shows how important thinking can be and also highlights many important aspects of successful portraiture.

When I was assigned to photograph Ali McGraw, I went to great lengths to 'buy time'. I asked if I could meet Ali at least a day before the shoot. I went down to the film set and explained over lunch that, although I appreciated her tight schedule, I wanted as much of her time as was possible so that she would have a chance to relax in front of the camera.

The trouble taken paid off; the shoot ended in a two-hour session, and the photographs all had a relaxed quality that would not have been possible had I gone in 'cold'. We agreed to shoot without a change of clothes for Ali, but the location made up for that with its great variety of backgrounds.

The subject is very relaxed, and is using one of the ornate columns of the conservatory as a leaning post. The location was chosen with the conservatory in mind as a retreat in case of inclement weather.

The facial contours are mirrored by the shape of the ornamental urn. Again the pose is relaxed and the gaze direct. The photograph is nicely balanced by the flowering shrub which also adds colour.

The dark green foliage in each of these pictures sets off the blue denim clothing beautifully. The upright shot has an unusually high camera angle, accentuating the leg spread by using a slightly wide-angle lens. The landscape picture has a low camera angle. A longer lens makes the subject stand out against the green backdrop.

Looking in from the outside has produced a totally different observed effect. The window sill provides something to lean on, and the glass acts as a built-in soft-focus filter. The window frame gives the picture a graphic quality and helps focus attention on the subject. This photograph has something of an 'at home' feel about it, achieved by a careful choice of location.

FOR THE FAMILY ALBUM/1

Taking pictures of family or friends is a standard assignment for any photographer, amateur or professional. The photographs may be quick snapshots for the family album or pictures to commemorate a special occasion, such as a birthday or a retirement. So how does the thinking photographer get the best informal portrait?

Couples are a common subject. They may be your parents, friends or total strangers. Two people pose special problems for a photographer: how do you place the subjects in a natural and complementary position? Location, too, may present problems. Houses and gardens can both be limiting and are often far from photogenic.

Posing is one of the most difficult aspects of portraiture to master. Getting people to relax is an art. Many people dislike being photographed and 'freeze' when confronted by a camera. You must try from the outset to put your subjects at ease. Standing is the position least likely to make anyone feel relaxed: leaning or sitting is much more natural. Try to keep talking to the people you are photographing — communication is all-important.

You must also be careful with lighting. Daylight is a good choice. However, direct sunlight can cause high contrast. Remember that film cannot record as great a range of subject brightness as the naked eye can see. Sunlight can also make people squint and produces harsh shadows, especially in eye sockets! Film instructions used to read, 'Stand with the sun over your shoulder', but these simple words of advice have ruined many pictures.

The informal portrait may be a familiar situation for a photographer, but there are just as many pitfalls as with an assignment into unknown territory. But if you STOP! and THINK! before you start, and develop the situation in a logical way, you can achieve a memorable portrait in the end.

The subject is an elderly couple in their garden. The 'at home' setting is a small garden with little obvious colour, a broken-down greenhouse and two garden chairs. There is a standard lens on the camera.

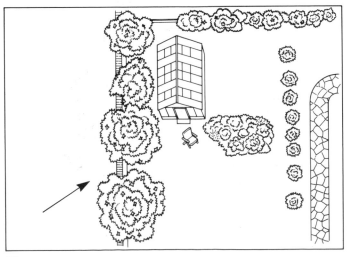

A plan of the site shows the confines of the working area: a small lawn, a few shrubs, some flowering heathers in the centre bed, the chairs and greenhouse, and the direction of the sun. These are the ingredients with which the thinking photographer has to work.

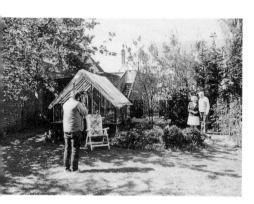

Positioning the couple is the first step. Many photographers would pick the one clear area where the sun is shining — the traditional 'sun over the shoulder' approach. This is not the best way to tackle the subject.

A 'first thoughts' shot with the approach described above does not produce a good photograph. The couple are small in the frame and squinting into the sun. No attempt has been made to relax them. The photographer has not closed in on his subject and there is too much clutter in the picture. This is an unthinking and unimaginative approach. The photograph records the scene and little else.

STOP! THINK!
Change places

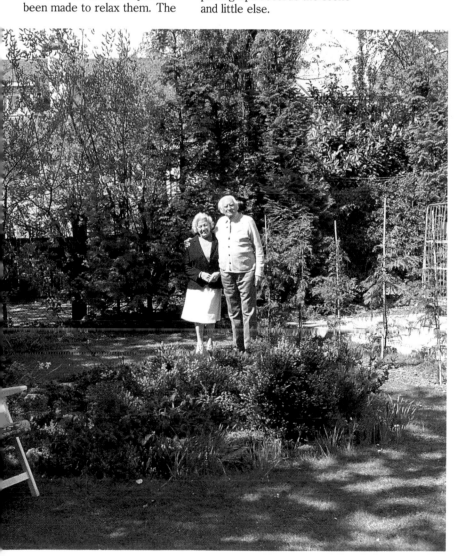

What happens if you 'break the rules' and photographer and subjects change places? With the camera now shooting into the sun, you must take care to avoid flare. Shading the lens with your hand or using a lenshood usually prevents this.

STOP! THINK!
**Make the sun
work for you**

FOR THE FAMILY ALBUM/2

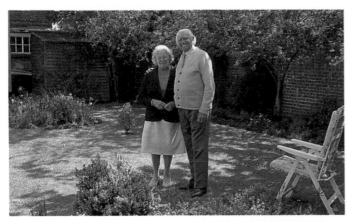

STOP! THINK!
Add some props

The sun can be made to work for the photographer rather than against him. The subjects can open their eyes fully, and they are pleasantly back-lit by the strong sunlight. The background, instead of being flat, has a dappled. three-dimensional look to it. The composition is still messy, however, with the chairs intruding on the right of the frame.

The thinking photographer is never totally satisfied. The two garden chairs that were lurking on the edge of the picture before might improve the photograph even further. Be careful, however, that they do not create different problems.

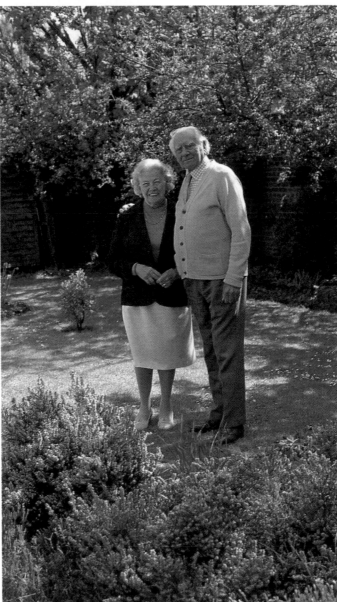

STOP! THINK!
Turn the camera

Simply turning the camera transforms the picture. By making it an upright, all extraneous matter disappears. The couple have relaxed as the session has progressed, and they are well framed here by heathers and shrubs. The lighting is good, so the picture has colour and depth. But do not be content to stop at this point.

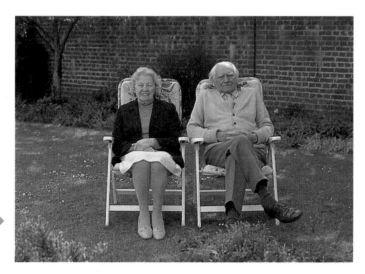

Greater informality is created with one of the chairs reversed and overlapping the other. The advantage of this arrangement is that the couple are close to each other and that they have to turn to look at the camera. Both actions clearly relax them. So far, however, the photographer has thought only about the subjects, not the camera angle.

STOP! THINK!
Take another look

People are usually more relaxed sitting or leaning, but here the addition of the two chairs has made the subjects as awkward and formal as they were in the first picture of the series. They automatically placed the chairs side by side and sat down facing the camera.

Positioning the subjects at different levels makes the picture more informal. By getting rid of one chair and turning the other sideways, one subject is sitting and the other has something to lean on. Even so, the picture still lacks impact. There are few options in this situation, but maybe more can be done with the chairs.

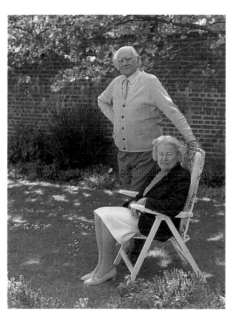

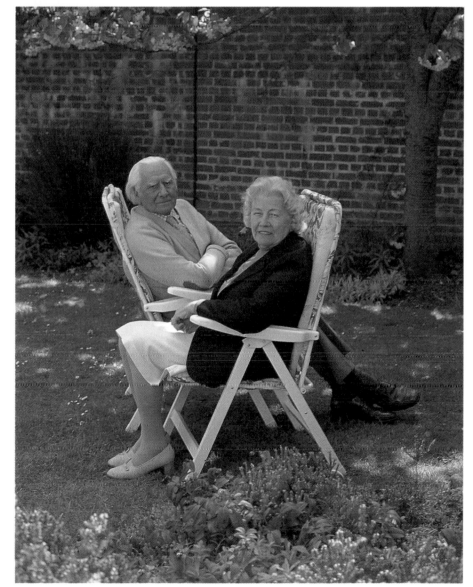

FOR THE FAMILY ALBUM/3

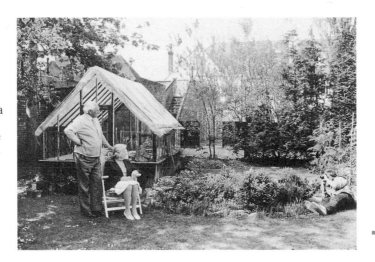

By getting down to it, literally, the photographer can make use of the flower bed as a foreground frame for the picture. He thus maximizes the colour of this extremely limited situation and adds depth to the photograph at the same time. There is no reason why pictures must be taken from eye level: the thinking photographer must always be flexible in his approach.

The foreground now adds interest, so the composition, pose, lighting and camera angle have all been improved. One final adjustment remains: moving the chairs closer to the flower bed and turning the camera once again makes the picture more compact. The couple now dominates the photograph but the colourful elements stay. So, despite an unpromising location, with clear thinking and a little imagination, the photographer has produced a good strong image he can be proud of. Both the landscape and the upright versions are equally successful portraits for the family album.

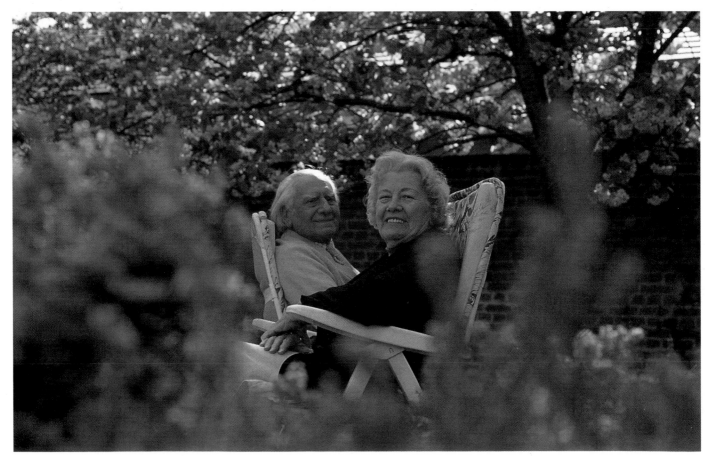

PHOTOGRAPHING CHILDREN

The best pictures of children are often taken when the subjects are totally unaware of the camera. Some children like posing, but the priceless moments in the life of a growing child are usually elusive, and the photographer has to be both observant and patient.

Anticipation is a useful attribute for a photographer, especially when taking pictures of children. These photographs are the result of spotting a situation, careful positioning in readiness, and quick reactions when it eventually happened.

I was driving down the main street in Castletownshend, a village in West Cork in the Republic of Ireland. I had just passed a young boy walking his puppy when I noticed a yellow and green fire hydrant. Anticipating what might happen when the puppy reached the hydrant, I hastily parked and waited.

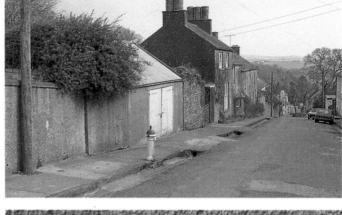

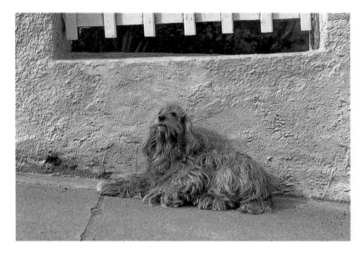

Another potential ingredient was a much larger dog lying peacefully outside his house on the same side of the street as the boy and his puppy. Would anything develop from this?

The meeting of the two as the older dog went to investigate the puppy passed uneventfully. The puppy pulled against his lead, but the potential for an outstanding picture was lacking. Eventually the bigger dog lost interest and returned to his spot.

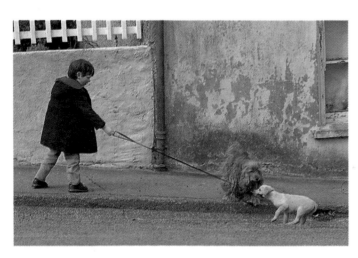

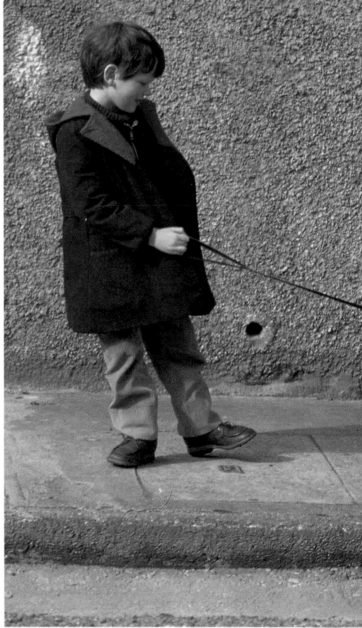

A lone fire hydrant in the main street of Castletownshend village offered the thinking photographer the opportunity of taking a great picture. In a situation such as this there is no time to waste and no second chance. Sometimes nothing happens, but you must prepare yourself in case it does. In this instance anticipation and patience paid off. The photographer waited on the opposite side of the road, to the right of this picture, so as to be unobtrusive.

Anticipation and patience paid off in the end. The puppy stopped to investigate the fire hydrant and the boy pulled on the lead. All the ingredients came together in a humorous, well-composed picture. Although the puppy is well away from the boy, the lead joins them together and guides the viewer's eye to the hydrant. The puppy's head turned and that was the moment to shoot. The thinking photographer 'sees' such a picture in advance.

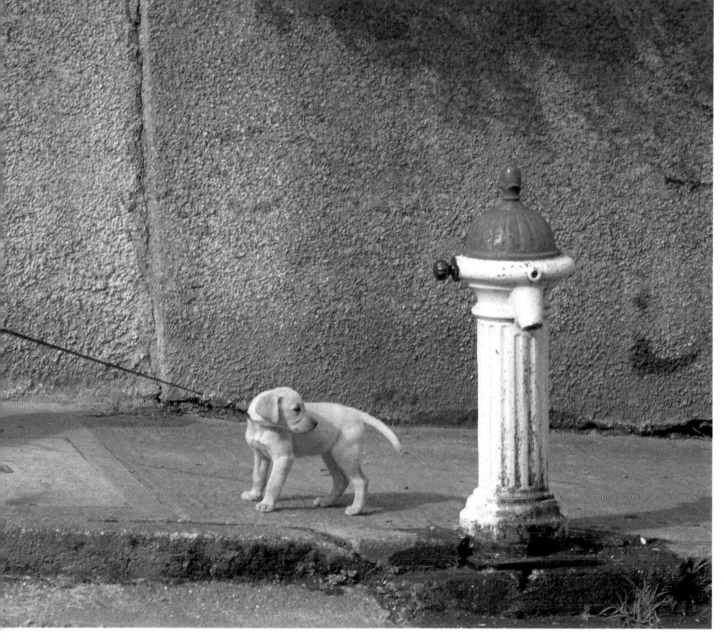

MOTHER AND BABY/1

Thousands and thousands of baby pictures are taken every week. The birth and growth of a child are, after all, some of the most memorable events of a parent's lifetime. Many of the moments you would like to capture cannot be re-shot, so it is worth spending time and money (on many rolls of film) in an attempt to take good pictures.

Babies can be photogenic, but people often wonder why the picture that looks so good through the viewfinder turns out so badly. Planning, thought and considerable patience are all necessary to get the best out of what is usually a difficult situation.

First, babies are often photographed at the wrong time. It is exciting to take a picture as soon after the birth as possible, but a baby's eyes cannot focus at that stage. Therefore a photograph taken then should be considered as one just for the record. The best time is from three months onward, when the baby can take notice of what is going on and has a wider range of expressions.

Second, baby pictures are usually taken in the home, and this location can be a nightmare for the photographer. Homes are invariably cluttered, and there are factors such as un-flattering light and colour to contend with. Always simplify your pictures so unwanted elements do not intrude.

Here and on the following pages I have illustrated the problems a photographer faces in a cluttered, dimly lit apartment, and how, with careful thought, it is possible to take a good picture of mother and baby. You may prefer a different shot from the one I achieved in the end, but with a step-by-step method you can explore a huge variety of possibilities.

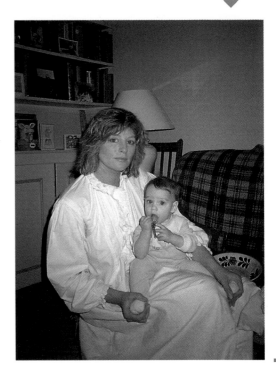

Straight flash deadens this picture. There is no atmosphere, and mother and baby are awkward and apprehensive. No attempt was made to frame the picture, and it seems as if the mother has a lamp 'growing' out of her head.

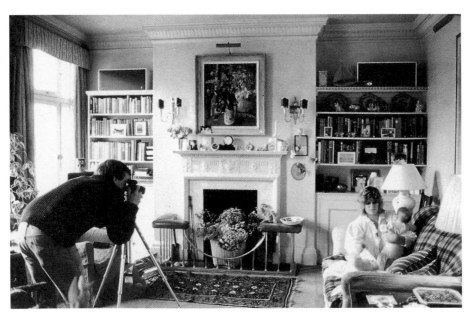

A view of the apartment shows a room full of furniture with little clear wall space. To make matters worse, builders had erected scaffolding at the windows. Here the photographer is taking a 'first thoughts' picture. He uses available light only and a tripod to keep the camera steady. A standard lens is on the camera.

A plan of the room shows that all the windows are on one side. There are some movable props, such as a basket of dried flowers, which will play an important part in the final picture.

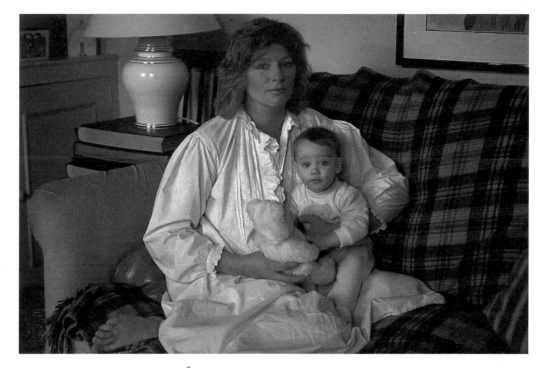

Natural window light softens the image. Mother and baby are still on the sofa, but the lamp has been moved away from the mother's head. But neither subject appears relaxed, and the large areas of white dress detract from everything else in the picture.

STOP! THINK!
Go in closer

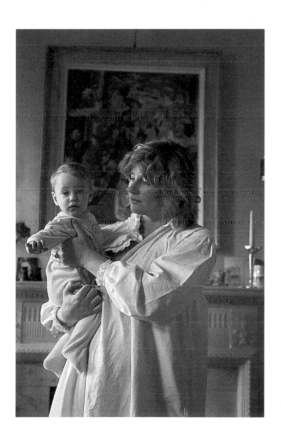

Mother standing by the fireplace improves the situation only slightly (*left*). The heavy black painting in the background is now the distracting feature. Also, the mantelpiece has a lot of small objects on it, making your eyes wander away from the focal point of the picture. The side light has, however, improved the lighting.

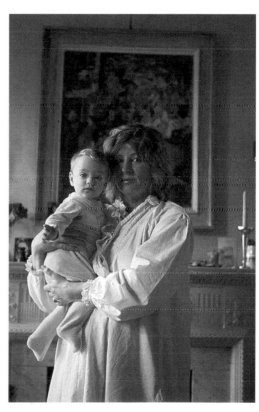

Bringing the subjects together (babies tend to pull away) meant that the picture acquired a cohesion (*right*) that it lacked before. But, held to the right, the baby blocks the light to her mother's face, and the problems of the background remain. It is time to STOP! and THINK!

MOTHER AND BABY/2

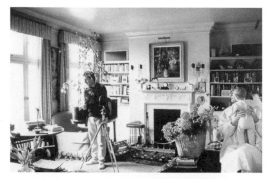

Going in close with a mobile foreground is the key to the next stage. A busy background distracts the eye from the subjects, so close in on the faces. There is little room to manoeuvre in the apartment, but there are movable props. Pot plants and a basket of dried flowers add colour and texture and are easy to position.

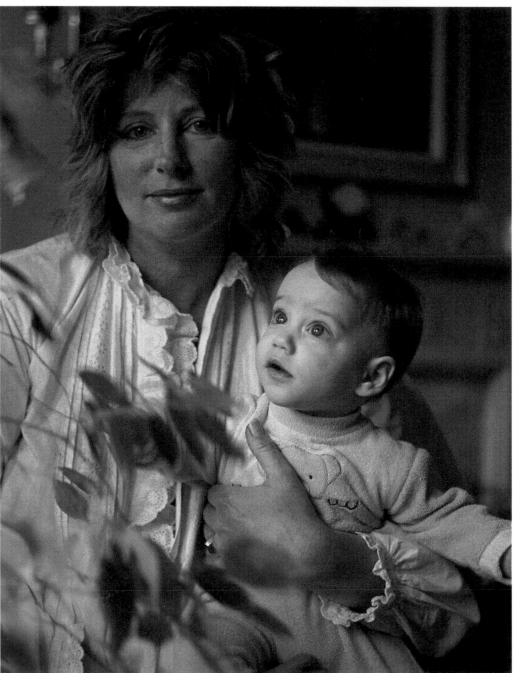

Soften the image by seating the mother closer to the window. The light is brighter and gives good modelling on the faces. The added contrast reduces the background to a deep, unobtrusive shadow. The plant in the foreground softens the picture and breaks up the white expanse of the mother's dress. This would be less of a problem in a bright, white-walled room, but with so much contrast here a large patch of white is not a good idea. As it is, the whole room is conducive to a low-key photograph, with large areas of shadow and little bright light.

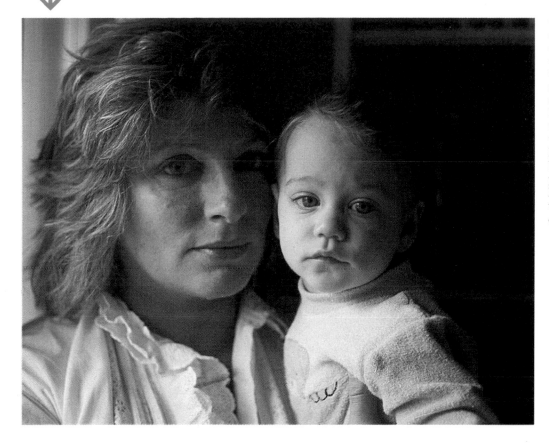

Cropping tightly by going in close with the standard lens solves the problem of the dress. The heads now dominate the picture. The background is minimized and there is good, strong side-lighting on the baby's face. The mother has turned away slightly from the window, however, putting half her face in shadow. But the baby is now interested in the photographer. Although the light is not good on the mother, this might be the time to go in even closer.

**STOP! THINK!
Back away
and wait**

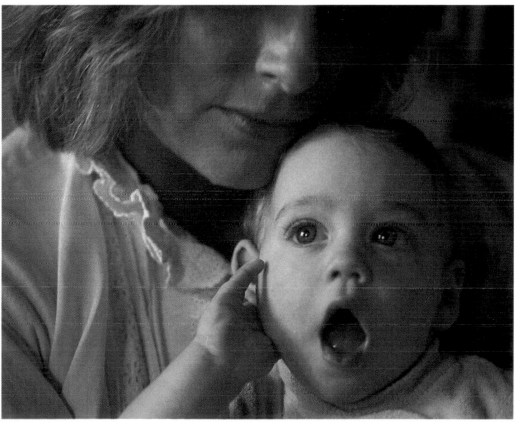

Coming in closer means concentrating on the baby. The viewer is still aware of the mother since part of her face is visible. Unfortunately, by going in close, a large patch of white dress to the left of the picture is distracting the eye. The photograph on the opposite page may, therefore, be preferred at this stage. So, back off and STOP! and THINK! again.

MOTHER AND BABY/3

The mother is repositioned by standing her against the window as she holds the baby to her. With the baby on her left again, light falls perfectly on both of them. By turning away from the window slightly, the mother has reduced the area of dress visible. Backing off means that the photographer balances the white area with large areas of deep shadow. Also, as the photographer retreats, the baby becomes interested in something outside the window. This, together with the beautiful, soft light, produces a relaxed study of mother and baby.

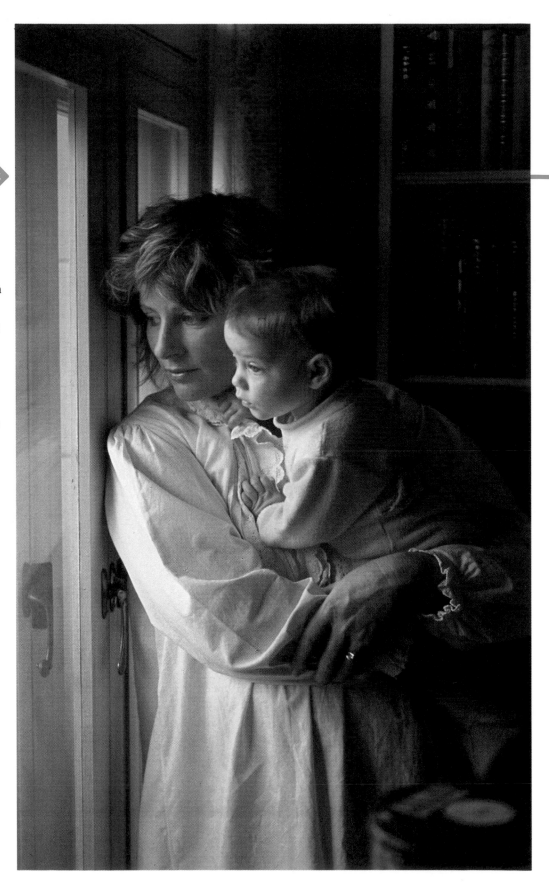

You must have the patience to wait for the right moment, having set the scene. By now the baby was tired and irritable, but there was one trick left — the rattle. Waved above the camera, it produced a spark of interest, and, with both mother and child looking up, the light falling on their faces was perfect.

Was there another picture possible? The picture opposite is more than satisfactory, but what would be the effect of using fast film in this dimly lit room? In fact, 1000 ASA 3M slide film gave a whole new dimension to the situation. A faster shutter speed was possible, which helped with a wriggling subject, and meant that the photographer could work away from the window.

The grainy quality gave an almost period feel to the picture. The mobile props now came into play. The photographer built a small set next to the only piece of clear wall, with the dried flowers providing colour at the bottom and the plant framing the picture at the top. The walls had an eggshell finish, which absorbs light and gives a parchment effect, emphasized by fast film.

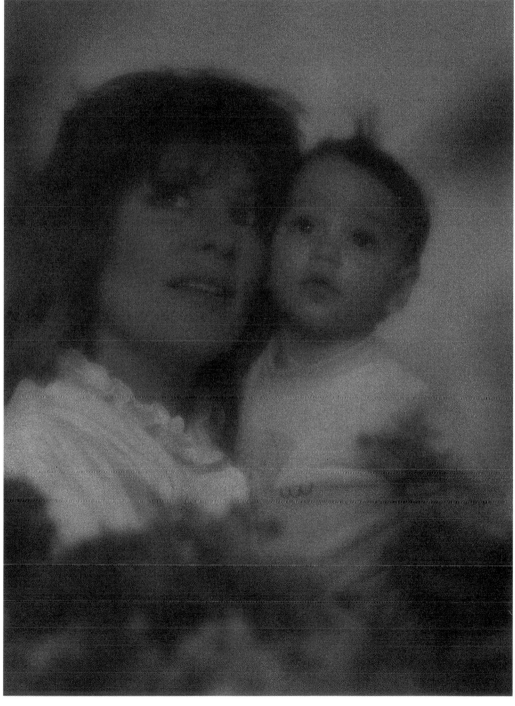

As the mother played with her daughter at the end of the session and made a fuss of her, lifting her in the air, the ever-alert, thinking photographer got one more shot.

FUN AND GAMES

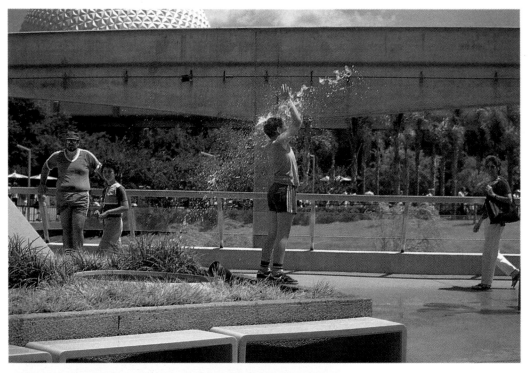

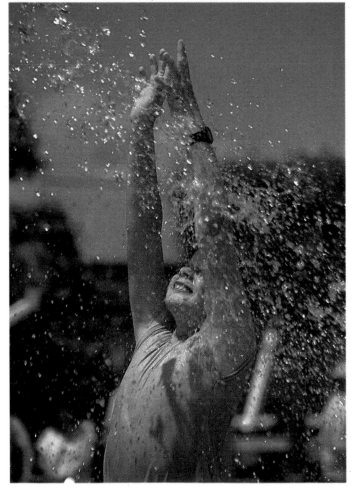

The leaping fountains at Walt Disney's EPCOT Center are a source of delight for tourists and photographers alike. In the Florida heat many visitors take advantage of a quick cooling shower, and this young boy is no exception. What is the best way to capture his enjoyment?

The angle here is too head-on. The sun is directly behind the photographer so the picture is flat, and the boy's arms cover his face. The water is totally 'frozen' into droplets.

By moving to the side, the thinking photographer gets it just right. The water is not completely stopped and seems to move across the frame. The face is clear and in profile, well lit by the high sun. Cropping tight and waiting for the boy to draw in his arms and throw back his head has produced a lively photograph. Deep shadow in the background throws the subject into greater relief.

THE WEDDING

Wedding pictures need not consist only of the set pieces you always see — the formal group outside the church or the ritual cutting of the cake. Often these pictures lack spontaneity, which is not always the fault of the hapless photographer. By biding your time, however, and using a little imagination, you can capture some truly memorable moments.

A photographer can be faced with many problems at a wedding. He has a limited amount of time, which puts him under pressure; he often has to compete for space with family and friends who also want to take pictures; and he may not really be the person for the job.

Many photographers specialize in weddings but, even if you are not one of them, you may still find yourself asked along in a semi-official capacity once people know you are a good photographer. The demands on you will be great, for the

traditional, posed shots as well as for the informal, intimate moments capturing the essence of the occasion.

So what should you do if you're asked to photograph a wedding? Plan as much as possible, but be prepared for everything to go wrong and expect to have to improvise. Most of the best pictures are not taken at the church, so be resigned to that fact. Take the required group shots but look elsewhere for the great photographs. Work quickly and shoot a lot of film. People will get in the way and those special moments will be all too fleeting. Remember, the occasion cannot be repeated and the proceedings cannot be held up.

It is a good idea to bring a flashgun, for although most of the action happens outside, there are always times in the church, if allowed, and in the car when reflections can be eliminated with a flash. Also a flash can soften harsh shadows.

The first opportunity to photograph bride and groom is often as they walk down the aisle. It is of necessity a straight flash shot. The usual angle gives a picture with little to commend it.

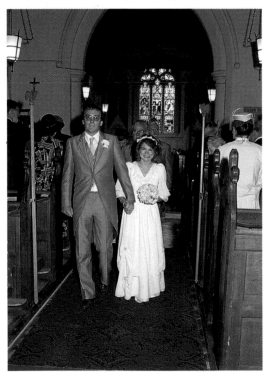

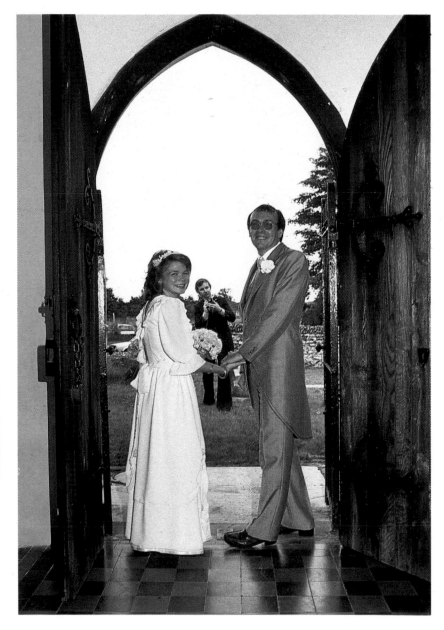

Take the couple by surprise, in this instance while the official photographer fiddles with his equipment. Following them outside, and using flash to fill in the shadows, produces a relaxed picture, with bride and groom nicely framed by the church door.

Unflattering light is often a problem outside the church, especially since many weddings take place around midday. You can use flash to soften the shadows, but such formal group shots although an adequate record of the occasion may still be disappointing. Here the light is harsh and emphasizes some unfortunate details, namely the ill-fitting morning suits hired for the occasion.

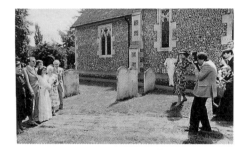

STOP! THINK!
Wait for a better location

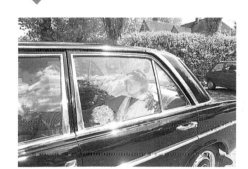

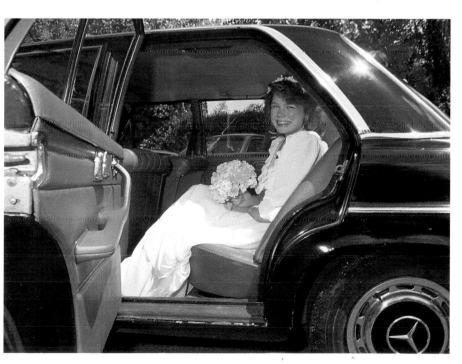

Unwanted reflections in car windows can often be eliminated only by using a flash. As the couple leaves the church, there is time for a quick shot, improved by opening the car door and, still with a flash, capturing the happy bride from a low angle. The best opportunities for good wedding pictures, however, are still to come.

RELAXED TECHNIQUES

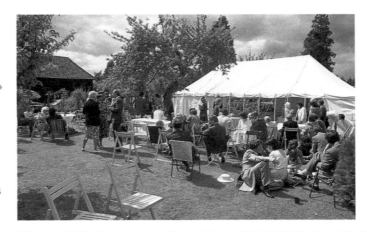

The reception is a relaxed affair and much the best place for informal pictures. Once the speeches and official presentations are over, there is time to look for and capture more intimate moments.

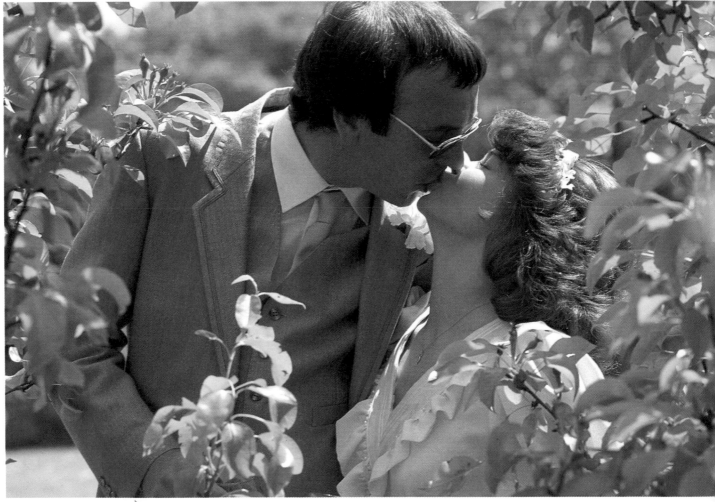

The standard 'kiss the bride' photograph often appears contrived as the guests look on, but this quiet moment is much more natural. With the aid of a small telephoto lens to avoid intruding upon a private moment, the photographer captures the bride and groom alone for a few minutes and unaware of the camera. The couple is nicely framed by foliage, and the happiness of the occasion is captured perfectly.

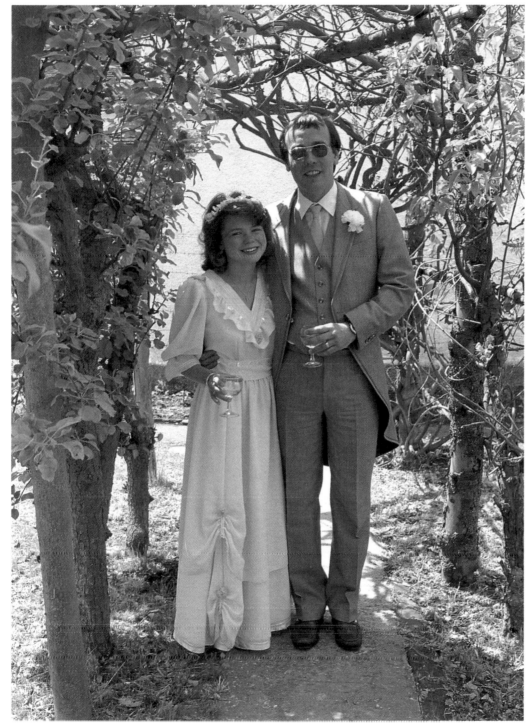

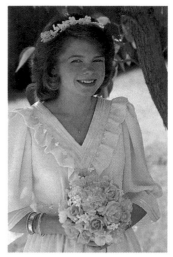

Soft lighting flatters the bride in this portrait and was achieved by positioning her under a tree. (Her bouquet was made of silk flowers and therefore remained 'fresh' throughout the day.)

STOP! THINK!
Look for the unexpected

The use of props — wine glasses in this instance — serves two purposes. It relaxes the hands: subjects often do not know what to do with them, especially if they feel at all self-conscious. Second, by placing the groom's arm across his suit, any untidiness is hidden.

The bride's parents with their daughter is another standard wedding picture, and the reception again provided a much more relaxed setting. It is not necessary to show the group full-length, and by holding the camera upright the picture is tightly framed.

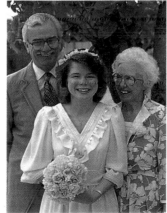

69

INFORMAL AND CANDID

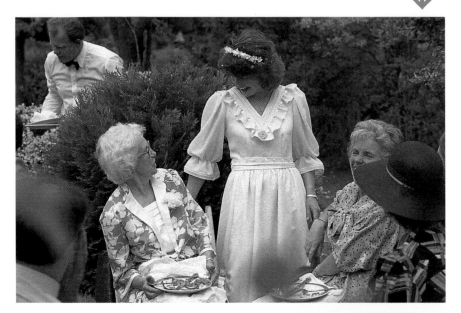

Intimate moments are best captured by keeping back from the action. While the bride was circulating among her guests, she stopped to chat to her mother and other relatives, unaware of the 'candid camera' approach of the photographer.

STOP! THINK!
Keep back from the action

One for the family album; this proves that photographers can sometimes make good subjects themselves. A good, steady camera position is shown here as a guest tries her hand at a snap.

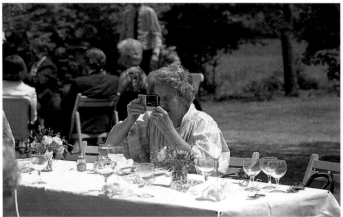

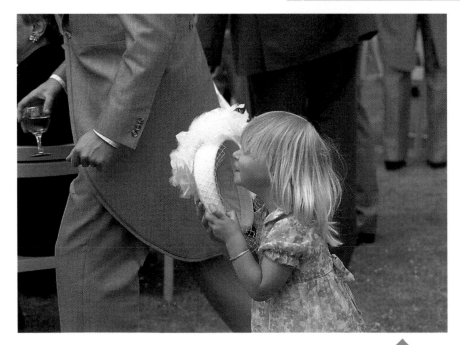

Be prepared for humorous incidents, such as a young guest making off with mother's hat. The tail of the morning suit in the background unmistakably says 'wedding'. A fast shutter speed froze the action here, and rapid focusing was essential to capture the scene in time.

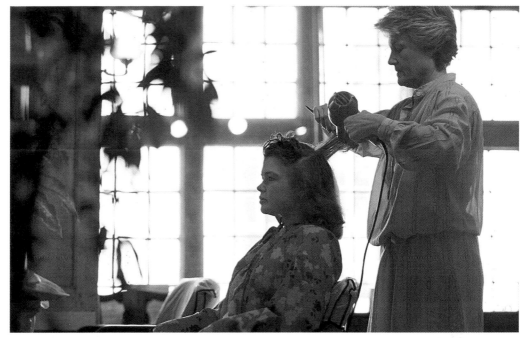

Pre-planning may get you behind the scenes on the wedding day. Ask the bride's permission to take pictures before the ceremony so that the full story of the day's events can be captured on film.

First we see the finishing touches at the hairdresser's in the early morning. Shooting into the light at the salon produces an unusual and candid shot of the hairdresser in action. A standard view in the mirror is enhanced by the bride's concentration on the positioning of the head-dress.

Finally, in the last few minutes as she waits for the car to take her to church, the bride is photographed through the open doorway of her parents' kitchen. Pictures such as these can be taken only with the family's consent, but they make possible a detailed 'day in the life of ' story to fill page after page of the family album. And remember with all wedding photographs that, because they cannot be repeated, they are well worth that little extra bit of effort (and film) on the day.

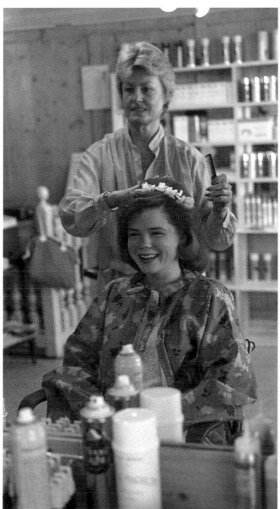

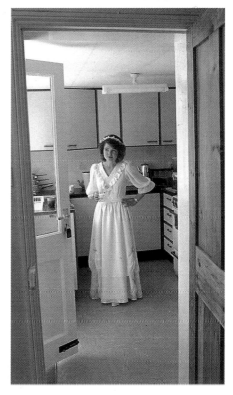

THE PHOTO-ESSAY

Telling a story in pictures is fun, as well as an interesting challenge for the photographer. The photo-essay is often used in magazine and book publishing.

The series of pictures must be wide ranging enough to show all aspects of the subject, so you will need to give it a lot of thought beforehand. But this does not mean you should ignore strong, single images: one picture can be the central point on which all the others hang. Also, be on the lookout for the unusual.

To show you how to compile a photo-essay, I chose a big event in Britain's horse-racing calendar — Derby Day at Epsom. This great occasion is not only for racing enthusiasts but also for ordinary people, who make a day of it, enjoying the many stalls and side-shows.

You must have a plan of campaign before you begin. In this instance, I knew it would be physically impossible to cover the whole of Epsom Downs and an entire 'day at the races'. I therefore decided to concentrate on the big race in the middle of the afternoon, and make this the central theme of the photo-essay. There was no point trying to take pictures by the winning post: passes were needed by accredited press photographers and there would be too many people at the rails to get a clear view. A favourite vantage point along the course is Tattenham Corner, where the horses sweep down into the final straight. I decided to take my main picture from here, so I planned the rest of the day with a view to being in that spot in time for the race.

To avoid heavy traffic in the vicinity and to catch any early-morning activity at the course, I arrived before 6 a.m. and looked for a scene-setting picture to open the essay. Unfortunately, there was a heavy mist, which lasted all day, so an overall view was not possible. I had to settle for a closer, general view of the caravans and stalls, with the grandstand looming eerily through the mist in the background.

When covering an occasion such as this, you must be prepared to improvise and compromise. Events go ahead despite the vaguaries of the weather. So, making the most of it, I started to record the early arrivals, the crowds as they built up, the fairground and all the characters I came across — not forgetting the bookmakers — trying to build a picture around the race itself.

You can make a photo-essay of many different occasions: a special event of any kind, a day trip, or a visit to weird and wonderful places. The same rules apply whatever you are shooting: plan well, get there early, stay late, be prepared to improvise, keep your eyes open for the unusual — and hope for a little bit of luck.

Setting the scene is the first step in the photo-essay. It was 6 a.m. at Epsom racecourse, and a heavy mist hung over the Downs. Stall holders and gypsies had already arrived to stake their claims to areas in the centre of activity. Despite the mist, the scene-setting picture had to be taken in the hope that the weather might clear later. (It didn't!) This picture gives a great feeling of anticipation and establishes an idea of scale. Had the photographer been any farther back, the grandstand would have vanished into the mist.

The early arrival of some race-goers creates a great sense of expectancy. For some people Derby Day is a full day out, and that means a picnic breakfast at the course. They bring all the equipment they need to cater for their wants throughout the day — umbrellas, barbecue, ice-box, chairs and thermos. If these people had been photographed head-on, the background would have been empty. As it is, the tents looming out of the mist add to the feeling of occasion.

A DAY AT THE RACES/2

As crowds start to gather, topless buses are much in evidence. Here straw-boatered visitors find a parking space near the rails. The sense of occasion is emphasized by the jaunty headgear. The rolling downland has conveniently provided the photographer with an elevated position for this picture, which improves the angle of view considerably.

This is also a day out for 'the lads', in contrast to the organized party above. Parking spaces are jealously guarded, and these young men are using the roof of their van as a vantage point. Again, because it is taken from higher ground, the picture has an interesting background.

The fun of the fair adds tremendous atmosphere to a big event such as Derby Day. Research before the event revealed that the fair did not start until midday; I planned the coverage accordingly because an empty fairground is a dreary place.

When the sun appeared briefly, a fleeting opportunity for creative photography was not to be missed. With an exposure for the bright sky in the background, the big wheel provided a strong silhouette to break up a set of misty pictures.

All kinds of colourful characters turn up at events such as this. A telephoto lens keeps the photographer at a distance and is the ideal tool for recording spontaneous happenings. Here, two musicians entertain the crowd.

A DAY AT THE RACES/3

Always be on the lookout for personalities. As he cantered down to the start, champion jockey Lester Piggott gave the alert photographer a chance of a close-up. This picture was taken before an early race. Derby runners take a cross-country route to the start of the main event, so it was impossible to photograph the jockeys prior to the start and during the race itself. Not even the most nimble of thinking photographers can be in two places at once.

The focal point of the day is the Derby itself. This is the professional's angle, and all the pre-planning on the part of the photographer paid off. Exceptionally large crowds at the race meeting meant that it was essential to take up position at Tattenham Corner well before the big race so as to be right on the rails. It is important not to have to leave your spot for any reason once you are installed, since you are unlikely to recover it.

This particular Derby was very much a one-horse race,

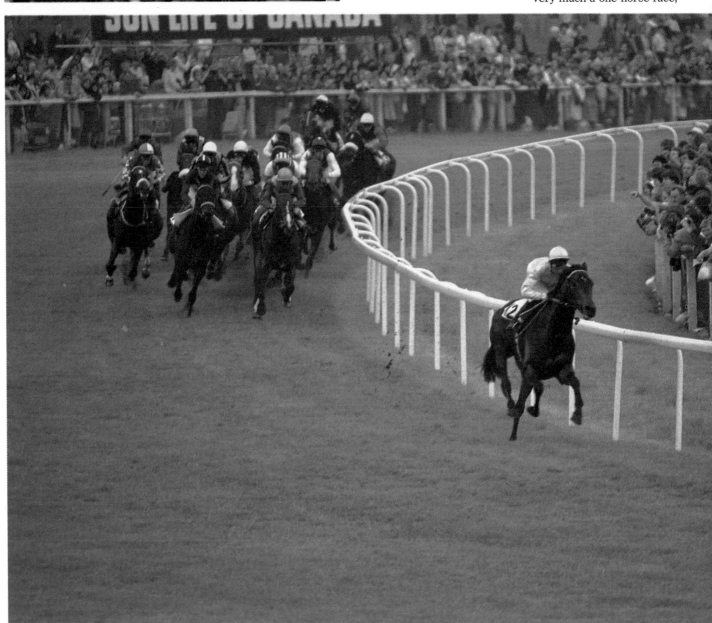

with Steve Cauthen leading by nine lengths at Tattenham Corner. A telephoto lens (300mm) compresses the chasing pack and the crowd. It was important, especially with the bad weather, to get this key picture, even at the expense of other possible angles, which might or might not have come off. When in doubt, go for the big one.

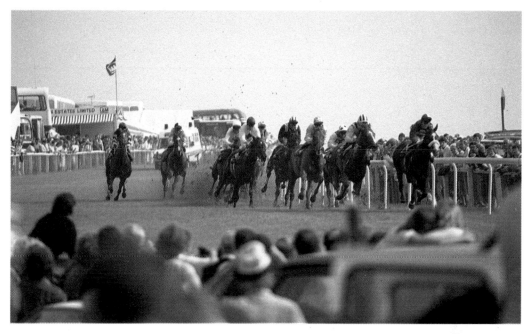

If you cannot get to the rails, use the crowd as a frame for your picture of the race. This was made possible by standing on a slight slope. It is an unusual angle, but it conveys the involvement of the crowd extremely well. An 80–200mm zoom lens again compresses the scene, which helps to link crowd and horses.

Take time to turn around at the start of the race. For bookies and race-goers alike, this is a time of eager anticipation: for the photographer, it is an opportunity to capture the tension in all the faces riveted on the action. This picture took no more than a few seconds, but it tells part of the story of a day at the races vividly.

A DAY AT THE RACES/4

The serious business of betting is best illustrated by the faces of the men to whom it matters — the bookmakers. They make excellent subjects for photography when oblivious of the camera.

People-watching is almost as good a sport as the racing, especially for the photographer on the lookout. These senior citizens, relaxing on the grass, were absorbed in the action on the course and quite unaware of the photographer.

A day at the races is thirsty work. Whether celebrating a win or watching the action, the race-goer needs 'watering'. In the VIP carpark, champagne is the order of the day as ticket-holders and their guests get in the mood before lunch. Morning dress is *de rigeur* at the Derby and, if it gets uncomfortably hot, more refreshment is called for.

Back in front of the grandstand, a bottle of beer is all that is needed to quench the thirst. Caught unawares by the telephoto lens, this example of how the other half drinks was shot between races.

The party's over and, in the VIP carpark, the more formally attired disrobe. This is a time to pause and reflect on what was and what might have been. The day's events are all over for the race-goers, but, for the thinking photographer, there is an opportunity to get just one more shot.

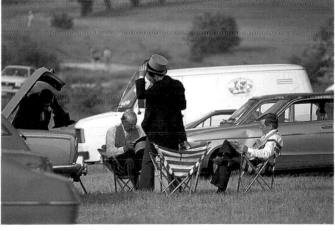

A STORY IN CLOSE-UP

Still-life photography, even among professionals, is a highly specialized business. Just one photo can take hours or even days of painstaking care. But the amateur photographer, too, can use still-life techniques, plus a little thought, to tell a good story in close-up. Everyday things or special occasions — a flower or a birthday cake, an award or engagement, even a birth — can inspire you to record the scene on film. A close-up can often tell the story much better than the overall view.

These pages do not tell you how to mastermind a complicated studio setup, but they will show you how, by thinking correctly, you can take a memorable shot. The first example is a popular subject for the family album. How many mothers go to a lot of trouble making a beautiful birthday cake for a child, only to find the picture they take doesn't do justice to all the hard work? Yet with a little care, a simple scene can become a good photograph.

A straight flash throws hard shadows across the table. Photographing a white cake in this way is a sure recipe for disaster.

The composition has been given no thought. The picture is not framed, and the chairs against the wall are messy and distracting. The plant in the bowl looks like a creature from outer space.

The lighting is much the same, but the flash was fired through layers of tissue paper to produce a soft, window-light effect. White paper was held up at the sides of the scene to reflect light back into the shadows, softening the picture further. There is still strong modelling on the cake due to the main light coming from the right of the camera. A longer exposure has picked up the warmth of the candle flames.

The addition of some relevant props improves the composition. The napkins to right and left hold the picture together and, with the forks, give a feeling of anticipation. A china bird fills the empty space in the foreground and the plant has become decorative.

The cake has been turned, and you can see the ribbon along the side. The plates are only partly visible, so they do not dominate but rather improve the composition. The feeling is now one of luxury.

THE PRIZE WINNER

Winning a school prize or trophy is always a time for celebration. Out comes the camera to record the scene for posterity and the family album. You may get lots of pictures of the sports day and even of the prize-giving, but when it comes to photographing the individual in his or her glory, winners and photographers alike can be disappointed.

Pictures such as the one on the right are too frequently all that remain of somebody's big day when, with a little thought, a winning photograph was possible. Here we have a teenage athlete who has just won his first trophy. Any proud parent would wish to preserve the moment. This is not the way to do it, although the awkwardly posed winner holding a silver cup is an all-too-common result.

So, how can it be improved? Assuming there are already pictures of the athlete himself, the most important feature here is the cup. All the ingredients are in the picture on the right, but it takes a thinking photographer to transform an ordinary picture into something special.

The athlete is clearly represented here, crouched in the starting position. His face is not visible, but this is not necessary.

The cup has a prominent position, cleverly framed by the athlete's hand and legs. The lines of the running track are reflected in the trophy, which adds interest and depth to the picture. This device demonstrates how well you can tell a complete story by getting in close.

A straightforward snapshot of the winning trophy standing proudly on the window ledge at home is a total disaster. Silver is difficult to photograph and here, reflecting the black shadows of the room, it looks dirty and uninteresting.

Why not put the cup in context? Placed in the centre of the track, it clearly reflects the lines of the running track. This ingenious still-life is a much more fitting tribute to the athlete's sporting achievement.

Plenty of space left around the subject creates the feeling of being there. The lines of the track add depth and perspective to the picture. A slightly longer lens than usual (135mm) was used to minimize the reflection of the photographer in the cup. This meant the picture could be shot from farther away.

The shoes also identify the sport. Arranged symmetrically on either side of the trophy, they too are reflected in it.

HANDS

The hands can convey a whole range of emotions — joy or grief, compassion or determination. As the subjects of still-life photography, and as elements in the art of telling a story in pictures, a shot of hands alone can speak more powerfully than any other.

Hands are a difficult, though rewarding, subject to photograph. They are not always still, so focusing has to be accurate. Working in close-up, whether with a standard lens or not, gives little depth of field, so the focal point is critical. Hands have texture, whether the subject is young or old, and lighting should be soft. Daylight, highly diffused flash or tungsten lighting are best to give good, even-modelling to the skin.

The angle of the photograph is important also: it is all too easy to make a hand look like a bunch of bananas. Like the human figure, hands look fatter in photographs than they are in real life. As always, stop and think before you shoot.

Reassurance is the theme here. A child was having a leg wound dressed in a hospital casualty unit. It was obviously a painful experience and the mother offered a comforting hand to see her child through the ordeal. That actions speak louder than words is perhaps the best caption to this shot.

A baby grasping its mother's finger is one of the first forms of physical communication between parent and child. This extreme close-up conveys an extraordinary strength and determination as the baby clings to its 'life-support system'. There is little depth of field here but it is not necessary, since the eye focuses immediately on the baby's fingers.

The tranquillity of old age is strongly conveyed in this picture. An old man was relaxing after a lunchtime walk, and the restful nature of the scene is admirably portrayed in close-up. The wrinkled texture of the skin shows up well against the handle of the old man's stick as he rests his hands on it.

In contrast, this was a carefully controlled situation. The photograph was part of a series taken of a couple to celebrate their engagement. It included a picture of the ring. In keeping with the occasion, the hand was posed on lace over a translucent white plastic sheet which was lit from below. White reflectors bounced the light back on to the skin, thus softening the picture. A piece of cellophane was placed over the lens as a soft-focus filter, and the photograph was slightly overexposed to keep the skin tones clean.

CARS ON CAMERA

Cars figure largely in our lives these days, and most people want to photograph them at one time or another. But even with 'one for the record' shots, the results can often be disappointing.

Some photographers take pictures of nothing else but cars, and this has become a highly specialized business. It is possible, however, with an ordinary camera and some careful thought, to take a good picture of your car. Running through the checklist of questions will help you a lot.

The first rule with car photography is to clean the car before you start — and not just the bodywork. There is nothing worse than a sparkling vehicle with muddy tyres. WHERE? is extremely important. It is no good parking the car, however clean, outside your house and trying to take a spectacular photograph. Think about the location. Where will the car be shown off to its best advantage? Should it contrast with the colour of its surroundings or be complementary to them? WHO? do you want in the picture, as well as the car? Would you like to be in it yourself? WHY? are you taking the picture? Is it just for the record or do you, perhaps, want to create an image of luxury?

The angle from which you view the car is important, too. Would it look more impressive head-on, sideways, or three-quarter front; from above or below? Finally, WHEN? is important. Together with WHERE? it largely determines HOW? you take the picture. Taking pictures of cars is a bit like photographing landscapes: the best results are often obtained early or late in the day.

If you want to be in the picture yourself,
set the camera up on a tripod and focus it carefully. Most cameras have a 15–20-second delay on a self-timer mechanism, allowing the photographer plenty of time to position himself in the picture. Think carefully about where you, or anybody else for that matter, should be standing in relation to the car.

The standard car photo,
— with the vehicle parked outside the house — is boring and muddled. The lighting is bad, and the car does not stand out from the hedge behind it. This is not an easy car to photograph because of its dark grey colour. The colour element will have to be enhanced by the lighting and background.

Location and time of day were all-important
in the end. There is nothing clever about the location: it is a public place but, since the picture was taken in the early evening, there were no traffic problems. The setting contributes to the luxurious look of the car, and the dappled, evening light adds colour and warmth to the picture. The headlights were turned on to complement the lighting. The photographer has positioned himself to the rear of the driver's door to avoid concealing interesting details of the car. This picture is far removed from the first one, but it needed only a little thought to achieve it.

SPORT AND ACTION

It is an unfortunate fact of life that major sporting events offer few opportunities for good action photography. The good action shot is a prized possession in many a photographer's collection, but coverage of the big moments in the sporting calendar is increasingly restricted to the professionals.

All too often the amateur can be seen firing a tiny flash on a simple camera from the back rows of the stands; this totally unthinking approach is often born of desperation. With the most popular sports, the answer is to take pictures on practice days, at a minor event where there are no big names playing or to face the fact that you have little chance of getting good pictures of, say, John McEnroe on court at Wimbledon or Forest Hills.

There are numerous other sports, however, where the amateur photographer is not only made welcome but where world-class performances will provide you with the opportunity to take good pictures. These are sports in which big-money sponsorship is not yet involved, in which the competitors are still truly amateur, and in which competitors' names do not reach the sports headlines. Any serious athlete appreciates and has need of good photographs, and will usually, therefore, cooperate happily with a creative, thinking photographer.

Try concentrating on sports such as judo, trampolining, shooting, swimming or canoeing. All these can produce stunning photographs and they are much easier to get.

Finally, you do not need to photograph sportsmen and women while they are actually competing. Given a little time and cooperation during practice sessions, the thinking photographer has more control over the situation. This is much the best way of getting sports pictures.

Karen Briggs is a world judo champion. She seldom reaches the sports pages of the world's newspapers, yet she is a great amateur athlete who relies upon understanding employers and minor sponsors to be able to compete at world-class level. She cooperated readily when it came to taking some action pictures of her.

Judo is a difficult sport to photograph. The action happens extremely quickly and usually against an empty background, so a lot of thought is necessary to produce a strong image. The two girls were back-lit with coloured lights and were asked to make the same throw twice on the same spot. The first time a shutter speed of 2 seconds was used to produce coloured blurs. Then, on the same frame of film, the photographer used flash to 'freeze' the action. So this double exposure not only has a still image but also traces of the throw. This gives a great feeling of the action of the sport. The same technique can be applied in many other situations.

GOLF

Use practice days for taking pictures of the big sporting names, especially if accredited photographers only will be allowed near the action during the major event itself. Here, Lee Trevino is photographed during his final practice round in the British Open Golf Championships. With golf, the timing of the photographic shot is difficult, and allowance must be made for the delay between the shutter release being pushed and the moment the shutter opens. In this picture, with the action frozen, the ball is a white blur as it speeds off the clubhead.

Timing is crucial, not only for the person taking the pictures but for the competitor himself. In this instance, the shutter has been released ahead of the stroke, but such is the speed of the clubhead that the sound of the camera will not reach the golfer before he makes contact, and so will not distract him.

Photographing sporting stars in close-up is easier on practice days, too. The relaxed nature of these sessions gives the photographer a chance to get a good portrait as the sportsmen pause to chat to the crowd or sign autographs. Take advantage of occasions like this to take 'professional' pictures; once the real battle starts, cameras may not be welcome.

Bunkers will always give you action. Sometimes golfers go for an entire round without hitting a ball into the sand, but on practice days they will often deliberately go into the bunkers to try out their recovery shots. They may well hit more than one ball, too, which means the photographer can have several attempts at a good action shot.

TRAMPOLINING

The problem of comparative size is well illustrated here as the camera looks down on world champion Sue Shotton from 10-12 metres above the trampoline. She is dwarfed by the apparatus. This is quite a strong portrait, but it lacks the action of the event. This session was helped by the athlete's willingness to give her time, since the sport is not widely recognized.

Using the trampoline surround as a colourful frame for this powerful picture, the photographer fires as the gymnast soars towards the camera. This photograph was tried with the athlete in a number of different positions, including horizontal to the ground. Perspective failed in that instance, however, and the viewer had no idea of the great height attained by the champion.

Finding the right angle for photographing trampolining is not easy. Trampolines are surprisingly large at close quarters, and the usual view from ground level leaves a lot of space between gymnast and apparatus. In this instance, the thinking photographer decided to use the trampoline as a frame for the picture by shooting straight down on the subject. A cooperative team of volunteers hoisted him up to the roof so that he was above the action. Several flash units, positioned to the side and underneath the trampoline, were triggered by photo-cells from the flash on the camera.

ROUGHWATER CANOEING/1

Exciting sports abound with action-packed pictures if you know how to get them. White-water canoeing affords many opportunities for the photographer, since competitors tackle the course one at a time, against the clock. So, although it takes only a few minutes for racers to negotiate the rough water, if you miss a picture of one, there will be another right behind. A further advantage of this sport is that you do not need a special pass, as for some popular events. You can cover the whole course, choosing the best positions from which to shoot.

A telephoto lens is an advantage but is not essential: a simple camera can take good action pictures. The trick is to think clearly about the camera position and to get your timing right. Rough water provides great action, but too much spray can obliterate the competitor. And, with so many vantage points, it is often difficult to work out where the best pictures will be. The course is not long, but, with both banks and a variety of water conditions to choose from, you must have a clear appreciation of the whole situation and be sure of what it is you want to achieve.

The first rule, as with any event, is get there early. Walk the course, talk to people who know the terrain. Note where the sun is and where it will be later on. Think about camera angles: would the best pictures be from water level or from an elevated position along the banks? Would the most exciting shots be in the roughest water? Is one bank better than the other, and should you be at the start or the finish, or half-way down the course?

With these things clearly mapped out in your mind, think about the effects you want to produce. Should the action be frozen by a fast shutter speed, or would it be better to use a slower speed and pan with the action to show movement?

There is plenty of time to think during an event such as this, but you can be as baffled by a lot of options as you can by a few. For the thinking photographer, however, a thrilling sport presents an exciting challenge and can produce some spectacular results.

At the start of the event, competitors face a drop over a weir into rough water. This is the natural place for a photographer to start too, since you can focus on the dropping point before the racer arrives. The sudden descent into the white water should make a good shot if the timing is right.

Timing is crucial. The picture on the left was taken far too late. The canoe has already hit the rough water, sending up clouds of spray which have obliterated the competitor's face. The timing on the right was perfect. The canoe is dropping and there is a great feeling of action from spray thrown up by the paddle. The competitor's face is clear.

Plotting the options along the course on a small map will help the photographer. The course is only about a kilometre from start to finish, and both banks can be walked easily. Slightly farther downstream from the start is the first stretch of rough water. The photographer here has a side-on view of the competitor.

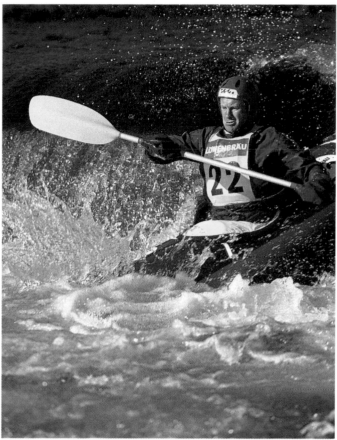

STOP! THINK!
Alter the lighting

Strong sunlight shows up the textures of water and rock. However, the picture lacks impact from this angle, although it is still a good action shot. A different location or a different effect will improve it considerably.

ROUGHWATER CANOEING/2

Shooting into the light has produced a totally different image, even though this was taken from the same position as the previous picture.

STOP! THINK!
Try an elevated position

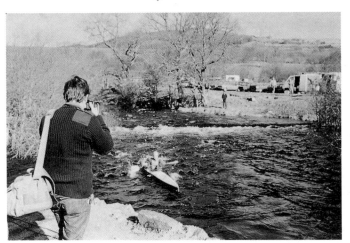

From an elevated position, the photographer looks down on the race in an area of relatively calm water. This does not help to convey the action at all unless a different technique is used.

By looking downstream and exposing for the highlights on the water, an almost night-time effect has transformed the shot. Timing was important again here: the shutter was released as the paddle entered the water.

STOP! THINK!
Tackle it head-on

Panning with the action of the canoe, together with a slow shutter speed, has produced a lively photograph, even though the canoeist is in a region of calm water. The photographer's elevated position is put to good use here: large areas of blue water add colour to the picture and the spray stands out against this background. Within a few metres of the start of the course, therefore, the photographer has produced a variety of pictures. But all his attempts so far have been from the safety of the bank. What about positioning the camera head-on to the action?
So STOP! and THINK!

ROUGHWATER CANOEING/3

An ideal head-on position in this instance coincided with the roughest water in the final descent of the course. The photographer positioned himself so that the racers came directly at him. Always be prepared to get your feet wet: the thinking photographer packs waterproof gear on such occasions.

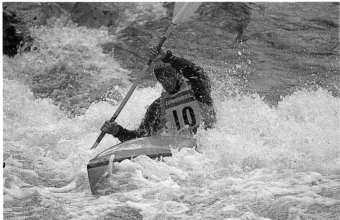

The subject was moving directly toward the camera, so the shutter speed did not need to be as fast as would be necessary were the action going across the frame. A slower speed meant that a tripod had to be used, since there is a tendency for camera shake with long lenses at slow speeds. Careful focusing was needed, too, since long lenses have a shallow depth of field. Creative cropping of the same picture increases its impact dramatically.

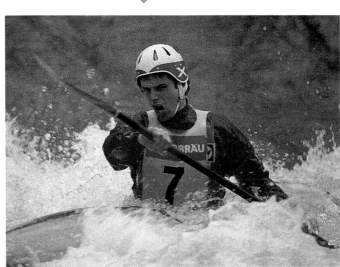

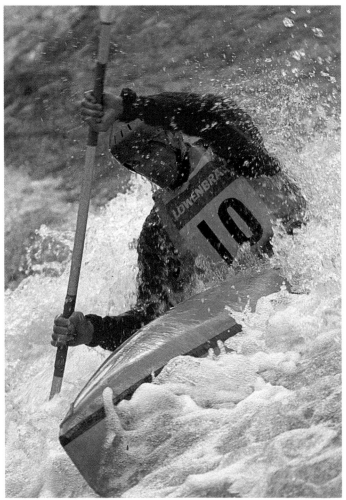

Zooming from this position offered exciting possibilities. This dramatic shot required a sturdy tripod, a slow shutter speed and a change in the focal length of the lens during the exposure. Even the most experienced professional photographer is never totally sure what the effects of this technique will be until the film has been processed. On this occasion the result was well worth the effort. Many photographers would be content with the coverage of this event so far, but there is always the possibility that somewhere an unusual angle has been missed. So, STOP! and THINK AGAIN!

STOP! THINK!
Look for the unusual angle

ROUGHWATER CANOEING/4

An unusual angle may easily be overlooked when there are so many other picture-taking opportunities. Halfway down the course was a small bridge under which the canoeists had to pass. This was rejected as a picture-taking position in the first instance because some advertising boards were in the way. Also, the action head-on was disappointing.

By standing on the bridge and looking down, the photographer found the one place on the course where the racers passed directly beneath him. A wide-angle lens was used this time so that plenty of rushing water would be in the frame, as well as the canoeist as he shot under the bridge. A fast shutter speed froze the action, and the bright sunshine saturated the colour to make an interesting and unusual picture.

THE MOVING SUBJECT

Action shots are not merely an ingredient of sports photography. There is movement in shots of everyday life — from a busy shopping centre to a flowing river, from children in the park to animals anywhere. And you can capture or even create motion. Clear thinking is necessary to decide how to act correctly in any situation.

Movement can be 'frozen' by a fast shutter speed. This method is often used in sports photography, where the photographer wants to record a particular moment and needs to 'freeze' the action, but it is not always the most effective technique.

A slow shutter speed gives a great feeling of movement. Blurring can be used in action photography, but it is also a good way to record rivers and people in situations that might otherwise look static.

Panning is a combination of the first two methods. You move the camera itself, following the subject, during exposure. The result is a blurred background but a subject in sharp focus.

By 'zooming', the photographer creates the impression of movement even though the subject is stationary. You operate the lens' zoom control during the exposure, giving an explosive effect to the picture. If the subject is centred, it will remain sharp; the edges of the photograph 'explode' outward giving the impression of motion. You can also use this technique on a moving subject with startling results (see p. 106).

The thinking photographer must consider carefully which method to apply in a specific situation and must have a clear idea of the desired result. Such decisions as whether to keep the camera still and use shutter speeds to interpret the movement, or to move the camera or the lens' focal length to create motion, have to be taken before you start.

The bustling floor of London's Stock Exchange requires a compromise shutter speed to convey the action while freezing certain details so that the viewer can identify the situation. It was necessary to observe the scene for a while before deciding the final exposure settings. Brokers who are on the telephone or deep in conversation are virtually still; others move quickly around the floor. A shutter speed of 1/2 second was used here to keep some figures sharp, while blurring others. Too long an exposure would have produced a totally blurred image. Too short an exposure would have ruined the busy atmosphere by freezing the scene completely.

HOW TO PAN

CHANGING

The choice of shutter speed can make a big difference to the end result. In this picture of a small waterfall in a fast-flowing river, a shutter speed of 1/250 second has stopped most of the water movement, retaining just enough in the foreground to give some idea of the speed of the river.

A 1/4 second exposure gives the same scene a different feel. The rushing water now appears as a series of white ribbons, although the rocks are still sharp. The same exposure was used, but as aperture size decreased, shutter speed lengthened, so totally different effects were achieved. This shows the choices available when you use blurring creatively.

Panning is following the action by moving the camera in the direction the subject is moving, in this instance a horse and rider jumping. You must move the camera smoothly, with good follow-through of the action even after the exposure has been made. A fast shutter speed would have stopped this action in mid-jump; it would still have been a good picture, but a shutter speed of 1/15 second gave a better feeling of speed. The shutter was released when the rider was against a background of trees so that the green blurs would add to the feeling of movement. Had the rider been shot against the sky, there would have been no streaks to convey the notion of speed. Background is extremely important with this technique.

The diagram shows how to take such a photo. Look at the subject through the viewfinder at an early stage. Swing the camera smoothly with the moving subject, which should be in the centre of the viewfinder at all times. Release the shutter at the peak of the action and follow through your action at the same speed.

THE SHUTTER SPEED

USING TIME EXPOSURE

ZOOMING

Vary exposure time — and also time of day — to dramatic effect. The San Diego Freeway in Los Angeles is a busy highway at any hour, but early morning rush-hour activity is frozen here by a short exposure. The sun, angling through the notorious LA smog, has neutralized the colour and produced an almost monochromatic image.

The still photographer can use the technique of zooming in a static situation to inject a sense of movement and urgency. Zooming is often used to great effect by movie and TV camera crews.

An accident victim is here being brought by ambulance to the emergency unit. The first shot was lit with flash and carefully exposed to pick out the lights of the ambulance. The nature of the emergency has, however, been totally lost in the picture.

Taken at night, the same scene acquires a totally different look. A shutter speed of 10 seconds has recorded streaks of red and white from the lights of moving vehicles. The brightly lit windows of the tower blocks and the deep blue night sky not only bring the image to life but create a great sense of movement. A sturdy base for the camera, or even a tripod, was absolutely essential for this shot.

A zoom lens injects a sense of urgency. Although the subject was almost stationary on the stretcher, a 1/15 second exposure made during zooming gave life to the picture. The ambulance crew and the patient were centred in the frame and so were hardly affected by the zooming effect. But the edges of the photograph have 'exploded', and the streaks of light from the sign and lights of the ambulance add considerable drama.

LANDMARKS AND LANDSCAPES

Everyone who owns a camera takes pictures of interesting places at some time or other, whether they be castles, churches, palaces, monuments, lighthouses or picturesque villages. The results are often disappointing because the naked eye can adjust and imagine conditions that are not recordable on film.

Photographing places is all about viewpoint, angles and light. So when you find yourself in an interesting place, how should you set about taking pictures? Stop and think about the viewpoint for a start. Where is the best place to take the picture from? Then, what about angle? You cannot change the nature of the place or control conditions, but different lenses can interpret the scene in different ways. Using a long lens from a distance or a wide-angle lens in close-up can be very effective. If you only have one lens, find the best vantage point and lighting conditions for that piece of equipment.

Light is extremely important. How does it fall on the subject? Many pictures are taken around midday, but this is when the lighting is at its worst, especially where buildings or views are concerned. Would the picture be better if taken earlier or later in the day, or in different weather conditions? Photography is a 24-hour business, even if it is only a hobby, and you should not disregard the possibility of taking pictures at night.

If you cannot return when light conditions are different, you will have to make the best of things. But with a little time and extra attention, you can transform an ordinary snapshot into a great photograph.

A magnificent castle always makes a good photographic subject. Leeds Castle in Kent, England, is in a lovely setting, surrounded by a moat, and has been beautifully restored to its former glories. But the day this photograph was taken was grey and rainy. There were no dramatic clouds to liven up the sky, and the grey castle walls matched the weather, making the scene dull and flat. The obvious thing would have been to return another day, but this was not possible. So the thinking photographer decided to wait until dusk, when the castle lights would be turned on and would be reflected in the moat. Just before the last of the daylight left the sky, a 4-second exposure brought the castle to life, with the reflections creating an intriguing second image. Much richer colours were brought out in an enchanting night-time picture, produced by the photographer biding his time.

THE LIGHTHOUSE/1

Famous landmarks are not necessarily photogenic. Neither are they always located in easily accessible places, even for the intrepid travel photographer. The Montauk Lighthouse in the United States is one such place. Situated at the extreme tip of Long Island, it is a destination for thousands of travellers. It presents an intriguing challenge to the photographer, having the Atlantic Ocean on three sides.

My first view of the lighthouse was short-lived, for a heavy sea mist came down. Adverse or rapidly changing weather conditions should not deter the photographer, indeed they may sometimes work to his advantage. On this occasion, however, conditions were far from ideal.

The Montauk Lighthouse is not one of the world's prettiest structures, and a common problem with photographing any lighthouse is background. Usually high against the sky, they can be less than impressive on film unless there are particularly dramatic clouds, which in this instance there were not. Also, lighthouses tend to be located on bleak promontories, and whereas the eye can sweep rapidly over the scene like a movie camera, it is extremely difficult to capture the setting in a single still photograph.

It took a great deal of time, thought and hard work to produce the final photograph in this series. Especially with the changing weather conditions, a multitude of different angles and viewpoints had to be tried, even if many of them were rejected. In the end, it was time of day and camera angle that played an important part in the final shot. Here, step by step, is how the shoot developed.

The first view of the Montauk Lighthouse is from the parking area, looking due east. Many visitors go no farther than this spot and take pictures from here.

Seen through the lens, the lighthouse looks unspectacular. The frame is messy and full of distractions such as the white lines on the road. The sky is flat and bland.

A plan of the area shows the lighthouse to have ocean on three sides. Since the sun sets on the land side of the lighthouse, the photographer might need a boat to get a sunset shot. There is not much high ground nearby either, so different angles and foreground effects need to be tried.

As the mist closes in, reducing visibility, so does the photographer. The idea here is to create a ghostly image, framed by the dark trees. The camera is turned to frame the lamp house in a vertical picture.

An atmospheric view of the lighthouse is the result. The dark trees and mist-shrouded lamp house are certainly effective, and the picture has a black and white feel, although photographed in colour. The view is limited, however, and the lighthouse could be any one of several rather than this notable landmark.

STOP! THINK!
Find a better foreground

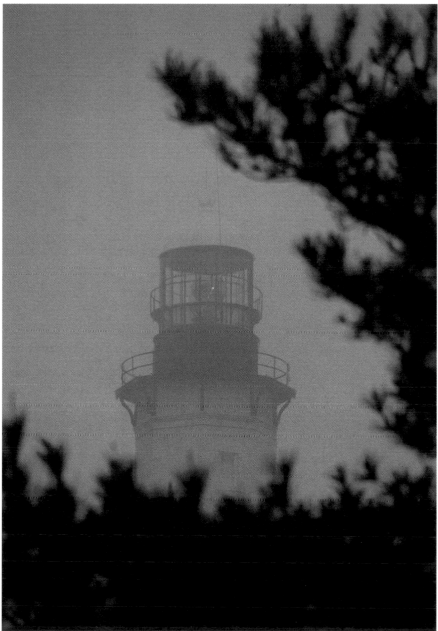

111

THE LIGHTHOUSE/2

Look for texture which against a flat, dull sky will add interest to the foreground. The branches of a thorn bush made a diamond pattern through which the picture was shot (*below*). A 200mm lens was used to throw the bush out of focus so that it framed, but did not intrude upon, the subject.

The picture now has colour and a strong, interesting frame. It still shows only part of the lighthouse, however, and tells the viewer nothing about its dramatic setting. This photograph is effective as part of a series of pictures of the Montauk Lighthouse, but by itself it does not say enough.

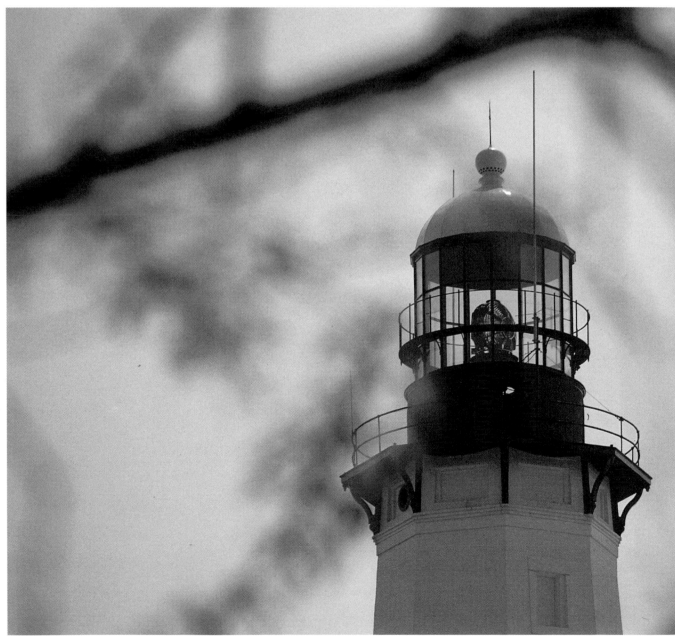

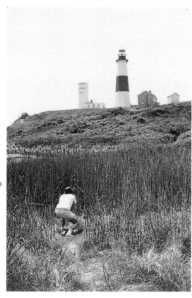

A different viewpoint is created as the photographer moves round to his left, circling the lighthouse towards the sea. Some dune grasses are now in the foreground and, since the sky is so dull, they might add some interesting texture.

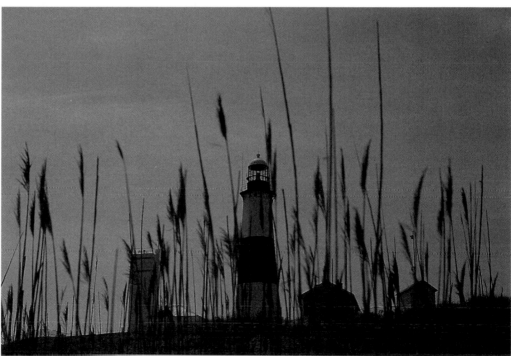

Abstract foreground shapes can be fun, and this wider shot shows the lighthouse *in situ*. The picture does not work well, however. The grasses are out of character with the subject and the silhouettes serve no creative purpose. It is time to rethink the photograph completely.

STOP! THINK!
Start again

THE LIGHTHOUSE/3

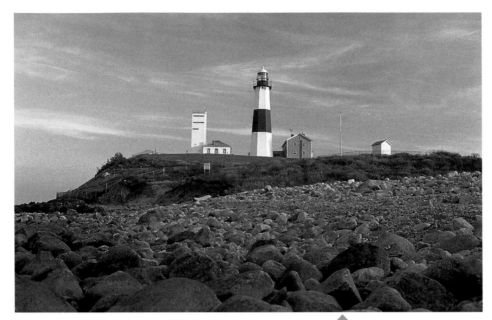

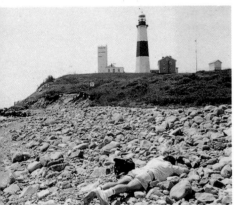

Lighthouses mean rocks and sea to most people, so, by walking to the edge of the ocean, the photographer gets the shoreline in the foreground. The lighthouse is now seen in context, but this is not the most interesting of shots.

Seaweed-covered rocks in the foreground frame the lighthouse nicely, but due to the very low angle of the shot, they have darkened the picture. Also, the lighthouse is relegated to the background.

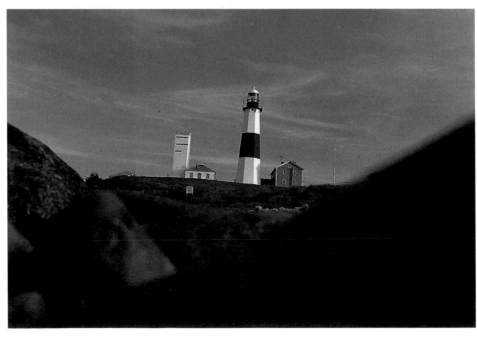

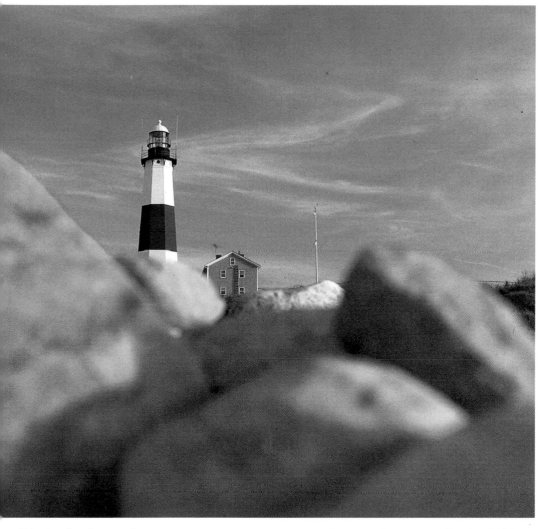

STOP! THINK!
**Find a new
viewpoint**

**Moving farther up the
beach** improves the picture in
two ways. The rocks are now
clear of seaweed and, with the
sun shining on them, they are
lighter and add warmth to the
photograph. The buildings are
larger in the frame, too. This is
an interesting treatment, but
maybe the picture can be
improved further.

A much more graphic image
is produced by turning the
camera into a vertical position
so that most of the picture is
filled by rocks. This is an
'unreal' treatment of the
lighthouse and it changes the
whole perspective of the
picture. It might look good in an
exhibition but has avoided the
challenge posed by the subject.

THE LIGHTHOUSE/4

Good composition makes this picture. It is well balanced with the tree, branches and shrubs all helping to draw the eye to the centre.

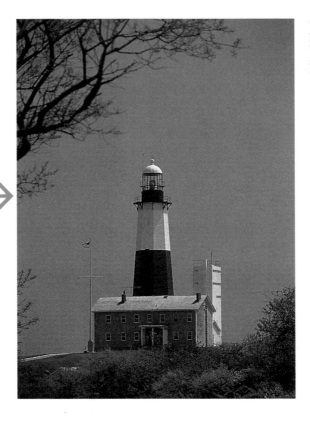

Back to the land now as the photographer, having explored the seaward side of the building, investigates the view from the approach road to the lighthouse. Backing off with longer lens, he uses the tree as a frame.

The final picture is basically the same as the one at the top of this page but, fittingly, lighting is the key to showing off the Montauk Lighthouse at its best. The finishing touches are the evening light and the angle of the sun's reflections as they fire the windows of the lighthouse buildings. A polarizing filter darkens the sky to emphasize this.

Time of day — the last trick in the repertoire of the landscape photographer — adds the element of drama previously lacking. Having found a good angle, the photographer needs better lighting. Crossing the road, changing the lens and waiting produced this wide-angle view. The change of light as the sun sets shows the lighthouse as a true beacon.

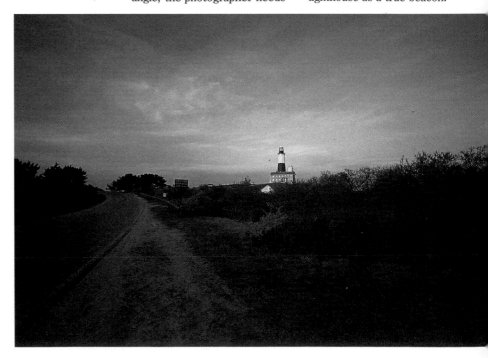

TIME OF DAY

WHEN? you choose to take a photograph can make or break a picture. The quality of daylight changes greatly from dawn to dusk, so the photographer must think carefully about how the time of day is going to affect taking pictures.

Photography is all about light. To produce a picture, light must pass through the camera lens on to the film, but the quality of that light is more important than the quantity. The photographer can use a number of light sources, from natural light to tungsten and flash, but for the average photographer daylight is by far the most common light source.

The colour of daylight, also, changes from sunrise to sunset. Many professional landscape photographers use a mobile home in order to be on the spot and take advantage of early or late lighting conditions. You do not need to go to these lengths, but the thinking photographer must be prepared to rise early, stay out late and be extremely patient if the weather goes against him.

As well as colour balance, the way light falls on a subject during the course of the day must be carefully considered. To show texture, light should slant across a surface, not fall directly upon it from the direction of the camera. Shadow is important in shaping a subject, to give it depth and contour.

Sunrise and sunset happen quickly and it is not enough merely to be in the right place at the right time. Often you have only a few seconds when the lighting is ideal. If, for example, you want to photograph the Lincoln Memorial in Washington DC from the far end of the Reflecting Pool (see page 124), there is not sufficient time to get to the other end of the pool before the light of the rising sun has moved off the statue. The photographer needs the ability to assess quickly the effects of different lighting on a subject and to consider time of day as part of his overall planning. As always, he must have a clear idea of what he is trying to achieve.

Although midday is often the worst time for photography, many pictures are taken then. The sun is at its highest, so people tend to have black shadows around their eyes, caused by the top light. The lower the light, the warmer and more flattering the picture. Many fashion shoots are done early or late in the day for this reason. The professional photographer often takes a rest in the noon-day sun, and you would do well to adopt a similar 'siesta' mentality.

Whenever you take pictures, be aware of the lighting, use it creatively, and remember it is not the quantity but the quality of the light that produces a good photograph.

Tower Bridge, London, just before dawn is bathed in light. This is a good subject to show how lighting changes, because the River Thames at this point flows northwest to southeast, and the sun moves across our view here during the course of the day. The early-rising photographer is well rewarded with this picture in the early morning light. A slow exposure has made the flowing water appear smooth, with the result that the bridge and HMS *Belfast* are dramatically reflected in the river.

Sunrise is one hour later, at 5 a.m., and already the colour balance is changing radically as the sun climbs above the horizon. A low light silhouettes the bridge and side-lights the moored ship.

The sun rises steeply to the left here, producing rapidly changing light and, in summer, passes overhead rather than behind the bridge. None of these or the following pictures was taken with a filter, so the changing light can be appreciated, and they were all taken on the same day.

TOWER BRIDGE/2

By 8 a.m. the attractive golden light of early morning has gone. This image is not as strong as the first two, although the angle of the light still produces an interesting effect. Exposing for the highlights has preserved the silhouette effect, but there is less impact than earlier on.

Midday is when many visitors to London might photograph Tower Bridge, but top light completely ruins the picture. The river is bustling with pleasure boats, and the bridge has detail, but the sky is flat and uninteresting. The picture merely records the scene.

In the late afternoon, around 5 p.m., the photographer has to contend with patchy cloud and the sun forever going in and out. The result is that in this picture only one tower is sunlit. The lower angle of the light produces a slight improvement upon the photograph taken at midday.

By 6 p.m. the low evening sunlight, falling fully on the bridge, brings the picture to life once more. The colour balance of the light has altered again, and there is now a warm, golden hue. The ship is well lit and a single pleasure cruiser adds interest in the foreground but does not detract from the subject. Early morning and evening have, therefore, proved the best times to photograph Tower Bridge, showing how crucial time of day is to the thinking photographer.

WASHINGTON MONUMENT

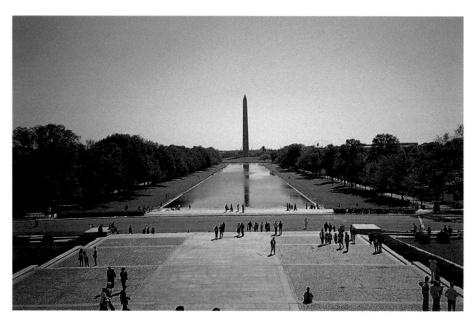

Crowds are a problem when photographing well-known landmarks during the day. An early start will not necessarily solve this problem since there may be other people with the same idea. This picture of the Washington Monument was taken early in the day, but already too many people spoil this view.

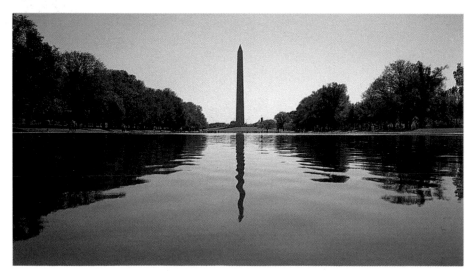

Even in the middle of the day, however, it is possible to get rid of the crowds by changing the angle of view. Getting down at the edge of the Reflecting Pool clears the foreground and makes use of the mirror-like qualities of the water. But the picture could still be improved. When would be a better time of day?

Dawn is a wonderful time for a landscape photographer. This is when the light is at its best. It may be a struggle to get out of bed early enough, but the results are often worth the effort. Here, in the early morning stillness, the Reflecting Pool is a perfect mirror, and the Washington Monument can be photographed in silhouette against the rising sun. The only inhabitants of the park at this hour are the ducks, one of which obligingly took off in the right part of the frame. A single exposure was all that was possible. The right time of day, together with a little bit of luck, combine to produce a strikingly beautiful image.

LINCOLN MEMORIAL

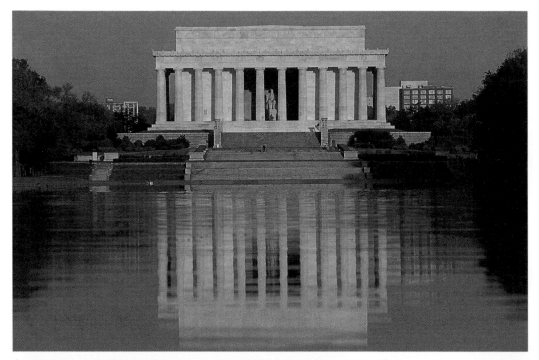

Some subjects can be shot only at a certain time of day. At the other end of the Reflecting Pool from the Washington Monument is the Lincoln Memorial. Only for a few minutes after sunrise does the sun illuminate the giant figure of Lincoln seated within the memorial building. Too early, and the pillars throw a shadow; too late, and the sun is high enough to cast shadow on the face. The ideal view, across the pool with the figure perfectly lit, makes a dramatic photograph.

The problem of shadow on the statue as the sun climbs high becomes apparent during the time it takes to walk the length of the pool. So you would need another early start to take a close-up of the figure fully illuminated. This head-on view, taken late in the day, is the most common angle, but there are other options.

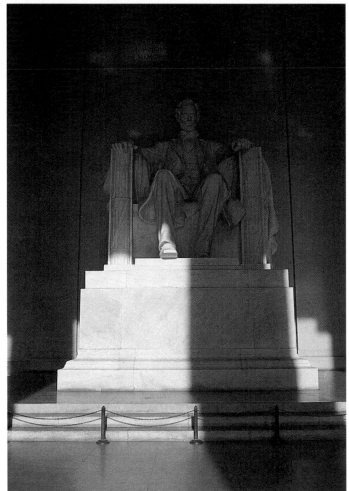

In the middle of the day, when there are crowds of visitors who tend to stand directly in front of the statue, moving to the side not only

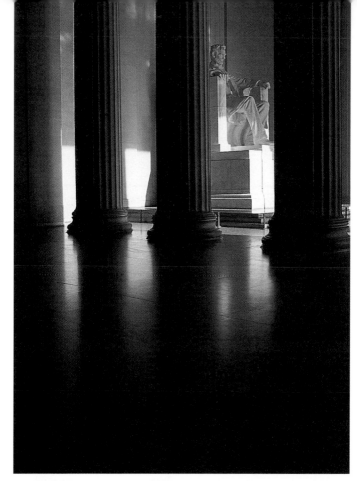

The large expanse of shadow at the bottom of the frame, contrasting with the brightly lit statue at the top, makes this a powerful picture. It is a striking, yet at the same time rather intimate, view. The pillars lit at the edges make a stark frame and, with the use of the upright format and the placing of the statue off-centre, the result is an unusual view of the Lincoln Memorial.

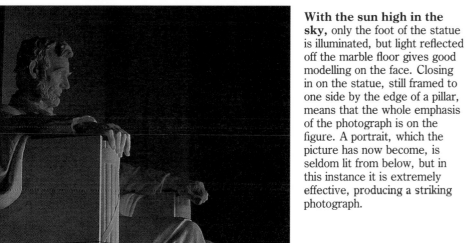

With the sun high in the sky, only the foot of the statue is illuminated, but light reflected off the marble floor gives good modelling on the face. Closing in on the statue, still framed to one side by the edge of a pillar, means that the whole emphasis of the photograph is on the figure. A portrait, which the picture has now become, is seldom lit from below, but in this instance it is extremely effective, producing a striking photograph.

eliminates the problem, but produces a new viewpoint. From here, the pillars can be used as a frame.

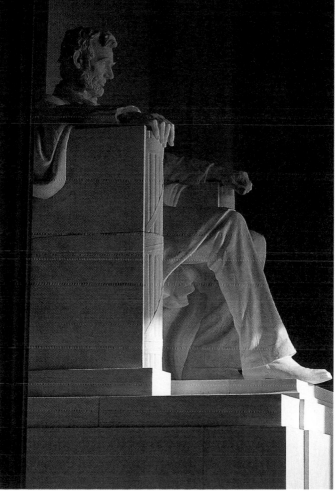

REFLECTIONS

Reflections can be a nuisance to a photographer, but they can also help him create some great effects. Unwanted reflections can be cut out by using a polarizing filter or by the careful choice of camera angle, and they can be minimized by controlling the lighting. Alternatively, they can be put to practical use. For example, a mirror in a room effectively lengthens, or widens, the appearance of that room, and when photographing in a small room, a reflection in a mirror can be as valuable as a wide-angle lens.

Modern architecture has seen the rise, literally, of more and more mirrored buildings. These can be put to creative use by the photographer, for example in contrasting the new building with surrounding architectural styles.

Reflections can also be used to create mood in a picture. You do not need to limit yourself to mirrors. Any shiny surface — a window pane, a shopfront — is reflective.

Many photographers make mistakes when shooting through glass. The camera should be placed right against the surface and the lens shielded to avoid extraneous light reflecting into the camera. If you are using flash, stand at an angle to the glass, otherwise the light will bounce straight back into the lens and ruin the picture. (You should treat any glass as a mirror, whether or not you are photographing reflections. If you cannot see yourself in a surface, then it is all right.)

On the following pages are some examples of the creative use of reflections, the problems they pose and the solutions.

Concealing the camera can be a problem when the frame is full of mirror images. This staircase in the Barbican Centre in London is a mass of mirrors that produces a kaleidoscope of colour. Photographing it presents a real challenge for the thinking photographer. WHERE? in this instance is not the location of the subject but the position of the camera so that it cannot be seen in the picture. It took many trials to find the only place where the reflection of the camera was blocked by the cross-rail, but this spot did not coincide with the best camera angle. In the end, a compromise was made: the camera and photographer are just visible in the bottom right of the frame but their presence is minimized by the power of this extremely busy image.

CREATING IMAGES

The standard view of the castle in Disney World's Magic Kingdom lacks any atmosphere. This most photographed of buildings has been pictured 'for the record' just as it has millions of times before.

The mood is changed completely by viewing the castle's reflection in the window of the saloon in Main Street. The soft-focus effect gives a misty, almost ethereal appearance to the castle, especially in contrast to the umbrellas of the pavement café in the foreground. The clever use of reflection here has created a mood, rather than merely recording a mirror image of the scene.

Modern glass buildings
in Washington DC offer the
photographer plenty of scope
for creative imagery. The
angled wall of reflecting panels
mirrors the street life of the
nation's capital in a fascinating
and exciting way.

An abstract image is
achieved by closing in. By
cropping out the surrounding
scene, this startling picture
gives us a unique view of the
city. The building itself clearly
says 'progress', but older
buildings and trees are
reassuringly part of the
reflected scene as the street
life goes on below.

OLD AND NEW

An interesting but obvious view of New York's high-rise architecture, this picture shows the old reflected in the new. It is little more than a 'snap', with no strong focal point and too much surrounding detail intruding into the image.

Closing in on the glass panels of the new building shows more detail of the old architecture in the striking reflections. This picture tells us little about the new skyscraper, however, and some of the impact of the old against the new is lost. There must be a better angle.

Capturing the whole of the skyscraper but retaining the reflected image of the building opposite, the thinking photographer has successfully brought together old and new in a most dramatic picture. By shooting straight up at the new building with its curved elevation, the old-style architecture is still clearly reflected in the lower panels of the skyscraper, while the whole of the new block makes impressive viewing. The street lamp shows that the camera was at ground level. It is not easy to get the exposure right in a situation such as this and the photographer must decide what his priorities are in the image. In this instance, it was felt that perfect exposure for the reflections compensated for the slight flare resulting from the overexposure of the sky. Indeed, the haziness at the top of the skyscraper actually enhances the building by emphasizing its height.

ELIMINATION TECHNIQUES

The eye tends to ignore reflections, but the camera does not. Eliminating unwanted reflections needs a little thought. Take a man wearing spectacles; if you were to photograph him head-on with a flash on or near the camera, the glass will act like a mirror and throw the light back into the lens. Thus the angle must be changed so that the light comes from the side or from above to avoid the reflections.

Photographing through a window also produces reflections if you are not careful. Put the lens close to the glass and shield it with a dark cloth. A polarizing filter is useful for eliminating reflections in windows or car windscreens. By rotating it slowly, the image of the reflection will be minimized or disappear altogether, depending on the strength and quality of the filter.

The basic rule is to treat all glass as if it were a mirror. If you cannot see a reflection through the lens, there will not be one in the picture. So STOP! THINK! and look before you shoot.

Pinpoint reflections in spectacles result from a double reflection of the light. The light here is, correctly, coming from the side, but by shooting through glass, which has reflected light back on to the spectacles, there is still the original problem of head-on lighting. With the glass pane in front of the subject eliminated, the side lighting cuts across the surface of the spectacles, illuminating the eyes of author Len Deighton.

Beautiful sunsets or dramatic cloud formations seen from aircraft windows often tempt the photographer. But the pictures may be disappointing with unwanted reflections creeping into them. The solution to the problem is to put the camera right up against the window, either with a rubber lens hood on it or surrounded by dark clothing. This will cut out reflections through the double layer of glass. This sunset over Iceland was produced in this way.

Shop windows highlight the problem of angled reflections. In the picture, a shopper pauses by a window full of distracting reflections of the street opposite. A polarizing filter was used to take the photograph below, and this time the camera can see into the shop quite clearly. A polarizing filter is an extremely useful accessory for the thinking photographer, not least because of its ability to reduce or obliterate reflections in windows.

FOCUS ON BUILDINGS

Photographing a building is like taking a picture of a giant still-life on location. Buildings do not move, which may seem obvious, but many photographers do not appreciate the implications of that simple fact. It means that you must keep moving in order to find the right camera angle and lighting.

WHERE? you take the picture from is all-important. Buildings are often surrounded by intrusive developments, so you may not be able to pick the ideal spot and get a clear view. You may have to work with only part of the structure visible. A choice of lenses may be an advantage, but ultimately the positioning of the camera will be the deciding factor. It may be necessary to climb up a neighbouring building to get the best view, or to back off and shoot from a distance. Sometimes shooting straight upward can be effective.

Wherever you are, the way the light falls on the building will be the second most important factor. In the end, you may need patience rather than great photographic technique to get the best results. When photographing buildings, therefore, take your time and keep moving around the subject, to assess all the potential viewpoints and changes of light.

A commonplace view of the square near the Plaza Hotel in New York includes all the elements of this much-photographed spot, but it captures little of the excitement of the city, with its impressive and varied buildings.

Moving to the right and turning the camera does little to improve the picture. But the inclusion of the sunlit building at the left of the frame should provide a spark of inspiration for the thinking photographer. This building could be used in a much more creative way.

Moving round still farther and reverting to the upright format has dramatically improved the view. The statue is silhouetted against the skyscraper and, by exposing for the brightly lit building, the photographer has produced a picture with a strong design of light and shadow. But the thinking photographer should not be content even with this.

Moving right around the statue, the photographer continues to use the silhouette technique, but the background is now an ultra-modern skyscraper, harshly lit against a blue sky. The colour of the sky has been deepened by using a polarizing filter. The result is a stark and powerful image that illustrates the benefits of exploring all the angles of view and being acutely aware of the lighting conditions.

135

THE GIANT STILL-LIFE

The conventional view of the EPCOT Center at Florida's Disney World is from the entrance to the park. It is easy to be overawed by this magnificent dome, but it would be a pity to settle for the 'one for the record' type of picture and not do greater justice to an ambitious project.

Dramatic lighting on the dome is emphasized in this picture by using a polarizing filter and exposing for the highlights, where the sun strikes the top of the building. The sky was, therefore, underexposed, creating a dark, moody effect. Having found the right angle and decided upon the composition, the photographer had simply to wait for the monorail to come along and to release the shutter when it was outlined starkly against the shadowy part of the dome. The result is a well-balanced, impressive picture.

Another familiar image of the EPCOT dome is across flower beds, which are beautifully maintained and full of colour. You might not think to bend your knees, but it is worth it for a slightly different angle.

An unexpected foreground, bright with colour, leads the eye to the focal point of the picture — the dome. But using a low angle, the photographer has cut out the heads of most other visitors, giving the impression that this is an exclusive view of EPCOT. There is a good sense of perspective, which again helps focus attention on the dome. The upright format means there is less empty sky than there would have been with a landscape format.

LOCATION SHOTS

Taking pictures of a town — whether you know it well or are just visiting — is not as easy as you might think initially. There is rarely a stunning view around every corner, so before you start you must pinpoint the architectural styles or the interesting details that will convey the feel of the place.

You will seldom find an elevated vantage point exactly where you want it to enable you to take an overall view. For instance, Sag Harbor, an old whaling port on Long Island, New York State, is an attractive town, but there is no high ground from which you can get a good picture. Even if there were,

large numbers of overhead power cables would spoil the view. The picturesque buildings must, therefore, be photographed in close-up.

In order to do this, you must walk. You will undoubtedly miss the most interesting places if you drive around in a car. Keep your eyes open for the unusual and be prepared to find a picture where you least expect it.

By following these few simple guidelines, you should end up with a series of photographs that admirably captures the character of the town.

A general view of the main street in Sag Harbor is without interest. Trees conceal the buildings and unsightly overhead cables dominate the scene. On the face of it, this would seem a difficult subject to photograph, but thinking in close-up is the key. Set off on foot, looking out for the unusual angle.

STOP! THINK!
Look for angles

Shapes and shadows make this a graphic study of a flight of steps leading to a porch. The colourful tulips basking in the spring sunshine and the texture of the wood are good finishing touches. This is not in itself a portrait of the town, but already the character of the wooden buildings in the old port is beginning to be established.

The white railings, photographed from the corner, create a powerful frame for the old clapboard house on Main Street. By moving in close, the photographer eliminates the power cables. The light is flat, but the wooden planks throughout the image give it a graphic quality.

STOP! THINK!
**Look for
colour**

PORTRAIT OF A TOWN/2

Spring is a colourful time, and the photographer should take advantage of it. This spacious, well-tended garden creates an impression of affluence and, although the image is dominated by trees and shrubs, the period feeling is retained by the inclusion of the porch at the left. Care is needed not to overexpose this type of picture. If you expose for the more shadowy parts of the garden, the highlights will lose their detail by burning out.

Isolate some colour by taking part of the house in close-up. Both shutters and plants help convey the feeling of a well-maintained, rather well-off part of town. An overall view of the house was not possible, but a close-up clearly shows the type of house in Sag Harbor.

STOP! THINK!
Frame your pictures

Hide unsightly objects by creating a frame for the picture. Above, the branch covers ugly cables, while the back-lit fence adds interest in the foreground.

Below, a view of the whaling museum uses the barred gate to cut out a boring expanse of driveway and to focus on the building. The top bar conceals the overhead cables.

STOP! THINK!
Look for the abstract

PORTRAIT OF A TOWN/3

Spotting the unusual as you walk through a town can provide pictures of the less obvious aspects of town life. Here, a dressmaker's dummy stands in the porch of a clothing shop. The exposure was for highlights on the dress, so the picture is tightly framed by strong shadows. There is an almost abstract quality about the photograph, yet at the same time it gives the viewer an impression of the town.

Make a record for posterity with your pictures. Everybody loves to look at old street or shop signs, but they are becoming rare. The window sign of the Main Street tavern shows Sag Harbor has not given up all its old-world charm. Photograph such things when you see them; they may not be there much longer.

Life in Sag Harbor is summed up in this picture, perhaps more than in any other. It is a strongly composed image that says clearly, 'peaceful, small-town America'. This scene too, was spotted as the photographer wandered around the back streets of the town. A simple close-up says it all — the smart clapboard houses with their neatly cultivated gardens. The tulips balance the bright colours of the flag, and both contrast with the dark rocking chairs. The impression gained from this graphic close-up is just as telling as it would be from a larger scale photograph of the town.

A QUESTION OF SCALE

It is often difficult to get an idea of the size of objects in a photograph unless there is a familiar reference point, and people are the most obvious points of reference. To see a person standing by a large building, for example, gives the viewer a good idea of just how big it is.

With smaller objects, and in close-up photography, there are other props you can use to show scale: matches, coins or pins are everyday items, the size of which everybody knows.

Put alongside the object to be photographed, the viewer can appreciate the relative sizes and get a sense of scale that might otherwise be missing.

There are many instances in photography when the scale of the subject matter ought to be made clear but is not; this is a frequent omission on the part of amateur and professional photographers alike. Below are some examples of how best to give an idea of scale.

Many visitors to the Lincoln Memorial in Washington DC are faced with the dilemma of how to show the whole monument, as well as family or friends. This picture is the all-too-frequent result. To include all of the building, the photographer has backed off so far that the person on the steps is reduced to a tiny, unrecognizable figure. This is a common problem when you want to record a 'being there' photograph.

The key is the movable 'object'. Both the photographer and the young lady are movable, but the photographer is in the right place, so she must come nearer to the camera. An auto-focus camera was used, with a flash to soften the harsh, midday sunlight on the face.

Pictures of the prehistoric standing stones at Stonehenge in Wiltshire, England, rarely do justice to this massive monument. The introduction of the figure of author Richard Adams — photographed in connection with his book *Maia* — gives the viewer a clue to its size. The standing stones serve a double purpose: they provide a suitable setting, reflecting the ancient, mythological nature of the book, and they make a powerful frame for the figure in this impressive portrait. The upright format of the picture mirrors the shape of the stones.

INTRODUCING FIGURES

The building on the island gives some idea of scale, but this picture lacks a focal point, which would make the shot much better. The location is Burgh Island, off the south coast of England, here photographed on a grey day with the tide in. The result is a large expanse of water, with nothing to direct the eye to any particular point.

The introduction of a figure into a landscape adds depth as well as scale. The galloping horse and rider also provide a point of interest, transforming a straightforward view into an interesting picture. Calmer weather and the expanse of wet, reflective sand at low tide set off the rider, and the late afternoon light also improves the shot. All these factors have a bearing on each other.

Scale is put to a different use in this picture taken off the island of Crete in the Mediterranean. The feeling of 'getting away from it all' is emphasized by the figures being small and 'lost' in an empty expanse of ocean. This was achieved by shooting the picture from the top of a cliff and deliberately filling the frame with nothing but sea. The figures give a clear idea of the depth of the water, and the picture creates a lovely feeling of warmth. This could be anywhere in the world — a timeless travel shot.

THE DRAMATIC PORTRAIT

In portraiture, scale can be used to dramatic effect, although an approach such as this might not immediately spring to mind. This was a professional assignment — to photograph the managing director of a ship-repairing company — and it seemed a good idea to photograph the man 'in the dock'. The dry dock was completely empty, which emphasized its vastness.

Posing the man in the bottom of the dock on the pier that supports the ship's keel created a wonderful sense of scale. The picture has been cropped to eliminate most of the dock walls, giving a stark, graphic quality to this portrait. The symmetry works to the same effect.

THE SILHOUETTE

Silhouettes are great mood enhancers; whether colour or black and white, they give a photograph a stark, graphic quality. They are usually achieved by exposing for the background to minimize detail in the foreground subject.

Exposure is the critical factor, especially when you want to retain a degree of detail in the subject. By stopping the lens right down, night scenes can be achieved at midday, with the sun taking on the appearance of a bright moon. Accurate focusing is important, also, to give clean, sharp edges to the subject.

Look for subjects to take in silhouette. Contenders will be those in which lack of detail will emphasize mood, and where the outlines are strong and stark. It is worth experimenting with this method of producing pictures with a powerful visual impact, but be discriminating in using the technique.

A clump of reeds by a lake is not immediately inspiring unless the reeds can be silhouetted dramatically against the backdrop of the sky.

Exposure is the deciding factor with this day-for-night effect. The photographer exposed for the bright evening sun, thus throwing the reeds into sharp relief. Exposure was judged to accommodate the reflections, and the lens focused on the reeds. A fast shutter stopped all movement.

The use of natural silhouettes makes an interesting landscape out of an ordinary scene. Here the picture was not shot directly into the light so the sky is still blue. By exposing for the highlights on the tree, the sky is darkened by underexposure, and the cows are in silhouette. Accurate exposure is important to keep detail in colour areas.

The splendid antlers of these Scottish highland deer cried out for a silhouette shot. Food enticed them into the frame.

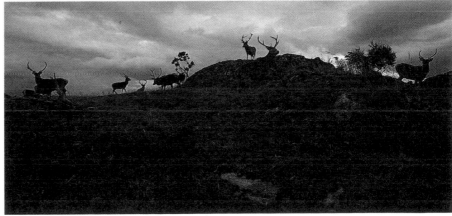

VARYING THE TECHNIQUE

A sense of timelessness is emphasized in this picture by the silhouette technique. The subject's grandfather used the same plate camera to photograph the sea and shipwrecks. Here, he and the camera, with its old wooden tripod, merge, silhouetted against the sky. The exposure was for the seascape, and the outline of the subject was sharply in focus.

In this shot, the shapes are more self-contained. The outlines of the silhouette are clean and sharp. The subject is standing back from the camera and is viewed from a different angle, with the undulating line of the rocks set against the sky. Although the sea is not visible, the rocks suggest it is not far away.

The playful mood of this young boy is beautifully captured in the warm evening light off Key West, Florida, by means of the silhouette technique. The ghostly, out-of-focus figures on the pier contribute to the abstract quality of the image. They do not intrude into the picture but help to fill the empty skyline, thanks to a 500mm lens and a small depth of field.

CREATING A MOOD

This lone fisherman is not an obvious candidate for an exciting image. There is no action, the shoreline is undistinguished and the lighting ordinary.

A sparkling background transforms the picture. Closing in on the subject with a telephoto lens and shooting straight into the reflected light on the water's surface produces a photograph with enormous impact. The exposure was carefully made to give minimum detail in the fisherman's face and arms. The photographer then had to wait for a little bit of action as the rod was cast. The resulting picture was a powerful study in concentration.

The unexpected silhouette, especially if the subject is set against an unusual backdrop, can provide a striking image. A woman driving a jeep down Sag Harbor (Long Island) main street caught the photographer's eye as she stood out in stark relief against white garage doors. Her semi-profile is emphasized by the outline of her spectacles. The open-top vehicle adds interest.

GLAMOUR PHOTOGRAPHY

Fashion or 'beauty' photography is a skilled and specialized business. Model, make-up, hair, clothes and location all contribute toward creating the mood of the picture. The photographic technique employed and the lighting, whether in the controlled environment of a studio or on location, must be carefully planned. This is the realm of the professional photographer, but the thinking amateur can get some excellent results too by thinking the shoot through in detail.

As an example, I have chosen an outdoor setting for a 'glamour photography' session: a model on a beach. Conditions are rarely ideal. You may lack the perfect location or the woman of your dreams. And this is only the beginning.

The next stumbling block could be the beach itself. Beaches in brochures always look smooth, clean and inviting, but in reality this is rarely the case. It takes a lot of thought and ingenuity to conceal dirty, ugly backgrounds. Second, you are unlikely to be working with a highly paid, experienced model. Your subject may well be a relative or the 'girl next door'.

So how should you approach a beach session? What are the pitfalls? And how can you make an inexperienced model look great? You must not be too ambitious. Keep the situation as simple as possible and, most important, concentrate on relaxing your subject. If she feels at ease, then you are half-way to taking great photographs.

For this step-by-step sequence of pictures, I deliberately chose a girl with no modelling experience and a beach that, although spacious enough to afford some privacy, was far removed from the golden sands of more exotic locations. This is the situation you are more likely to face, either on holiday or if you wish to try your hand at glamour photography.

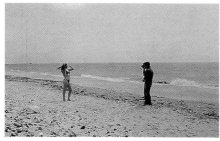

STOP! THINK!
Lower the angle

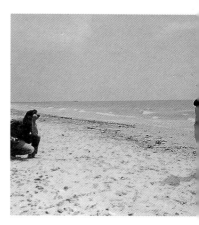

Your first thought may be to take the girl to the water's edge, stand with the sun high behind the camera and take a picture at eye level. When you see the result, you may wonder what went wrong.

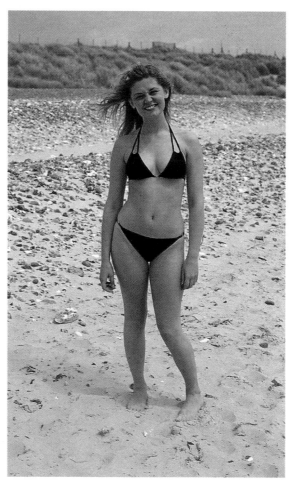

This clumsy pose is a typical result. Everything about this picture is wrong: the girl is standing awkwardly and does not know what to do with her hands; she is squinting into the sun; and the camera is looking slightly down at her, which is unflattering to the figure. The shoreline cuts through her head, and the beach is a mess. But many holiday snaps turn out just like this picture.

Correct the girl's position by lowering the camera angle and turning the girl so that she is back-lit and you are shooting into the sun. The sea is now behind the girl, which improves the background.

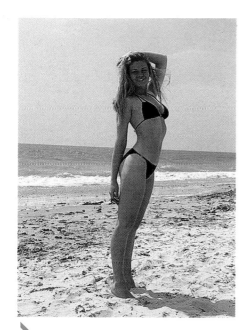

STOP! THINK!
Try a different pose →

Turning the body slightly away from the camera has a slimming effect. With one hand on her head, the outline of the girl's body is now clear. She is standing on her toes, which improves the leg line. It is difficult, however, for an inexperienced model to cope with all the elements of a full-length shot. And the beach is still messy.

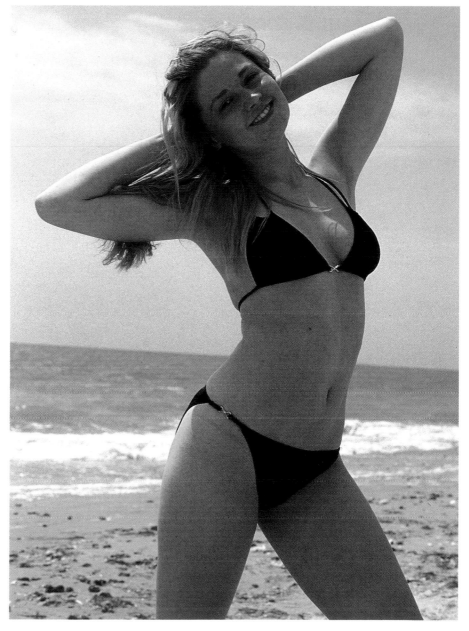

Cropping the pose to the thighs means that the girl has to stand in a less awkward position, and the extent of the beach is reduced. Hands can be a problem: an inexperienced model does not know what to do with them, and an amateur photographer does not know what to suggest. By placing her hands on or behind her head, the model clears the body line and, by tilting the upper part of her body, gives a curve to the waistline. Watch for wrinkles around the waist if she bends too far. This is one of several 'fail-safe' poses used by professionals the world over.

ON THE BEACH/2

Explore new camera angles and a different position. Sitting or kneeling is more relaxed than standing. Here the model is moved nearer the water and a low angle is used.

STOP! THINK!
Vary the exposure

Slight overexposure of the skin is necessary to make it look smooth and flawless. If you are shooting into the light, judging the exposure for skin tones can be tricky. It is best to try a few different readings.

Too far forward: this viewpoint does not flatter the legs which appear disproportionately large. With this pose, the model should point the toes and 'sit tall' so that the body stretches out smoothly. The hand on the head helps the body outline.

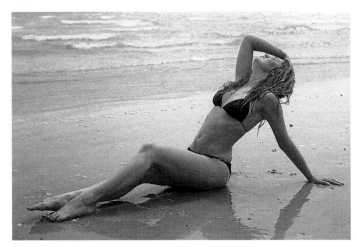

Too far behind: the legs are shortened, while the hand on the sand looks too large. It is worth trying different camera positions, but in this instance neither the three-quarter front nor the rear approach adds anything to the picture or flatters the model.

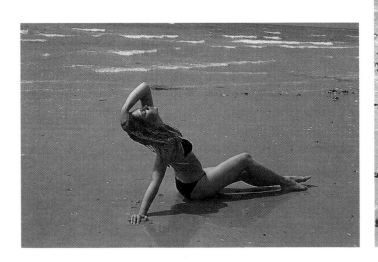

ON THE BEACH/3

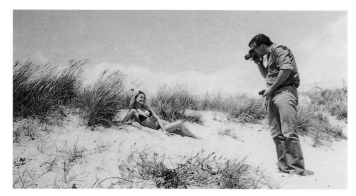

Grass and sand add different textures and, with a high camera angle, can be used to frame the model. Moving her away from the water has provided a more interesting composition.

STOP! THINK!
Return to a sitting position

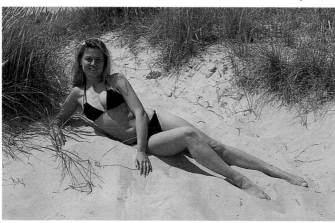

Beware of the sun on the model's face. Although the camera angle is good, the lighting is patchy, with streaks of sunlight over half the face. The pose is relaxed and the picture well framed, but it lacks impact.

Kneeling in the wrong position can be disastrous, so do not go for the cut-off look. The legs look thick and awkward. Too high a camera angle and harsh lighting combine to make the model's figure look bad. This is the kneeling equivalent of the first picture in the series.

Sitting the model higher up in the dunes and maintaining the upright format have produced the start of a good photograph. The grasses are well placed behind the subject, but the lighting is patchy and her legs are awkwardly posed. The model's hands, too, are uncomfortably placed.

STOP! THINK!
Go for bolder images

Tighten up the pose by swinging the legs around and carefully balancing the position of the hands. One hand can now be used to hold back the hair. By turning the model, the lighting is even on the face and, although the photographer is shooting into the sun, this is a much more elegant and relaxed pose, helped by the 'sitting tall' position. This fluid pose mirrors the tall, sweeping grasses, but a bolder image still is possible.

ON THE BEACH/4

Reflect light back off the sand on to the model, in this instance simply by means of a beach towel. Here the model is posed on top of the dunes in a small clearing framed by dune grasses. The photographer is now shooting against the sky.

The clear sky emphasizes the body shape. Tight cropping and the model's closed eyes create a feeling of luxurious warmth. The body is stretched to avoid skin creases, so easily overlooked with this pose. All you need is a standard lens and a beach towel.

STOP! THINK!
Use another lens

With a zoom lens, the thinking photographer has made a glamorous portrait. Although he has ignored all the obvious elements of the seaside, the model's bikini gives a hint of location. A combination of long lens and fairly slow shutter speed has thrown the grass out of focus. There is a feeling of wind-blown freshness and exhilaration, emphasized by the model throwing back her head. The hair is off the face, the neck is stretched, and there is soft light on the face.

NUDES

Photographing the nude is probably the most difficult form of photography and it brings its own unique set of problems. Many a photographer has been at a loss when first embarking on a nude photography session, but there are a few basic guidelines you can follow.

The first problem could be the model. Unlike a photography session on a beach, where your model could be a relative or a friend, it is rare that an inexperienced model will relax sufficiently for nude photography. Nevertheless, it is essential for the photographer to know the model: good communication between the two is extremely important. There is a fine line between a picture that is tastefully executed and one that is not.

Unless the session is in a studio, privacy may also be a problem. While many people think nothing of topless or nude sunbathing on the resort beaches of Europe, it is quite a different matter when there is a camera present. You will, therefore, have to choose a time of day when other people are not around.

Planning is the key. Consider the location well in advance and allow yourself plenty of time. Never rush a session, and settle for a few really good photographs rather than a lot of average ones.

Nude photography can be humorous. There is no reason why photographer and model should not enjoy themselves, and fun is no more out of place here than in other realms of photography. This model on a Tunisian beach had cast off her bikini top for a spot of peaceful sunbathing. The matchstick man, drawn in the sand, provided a body for it and an amusing companion for the girl.

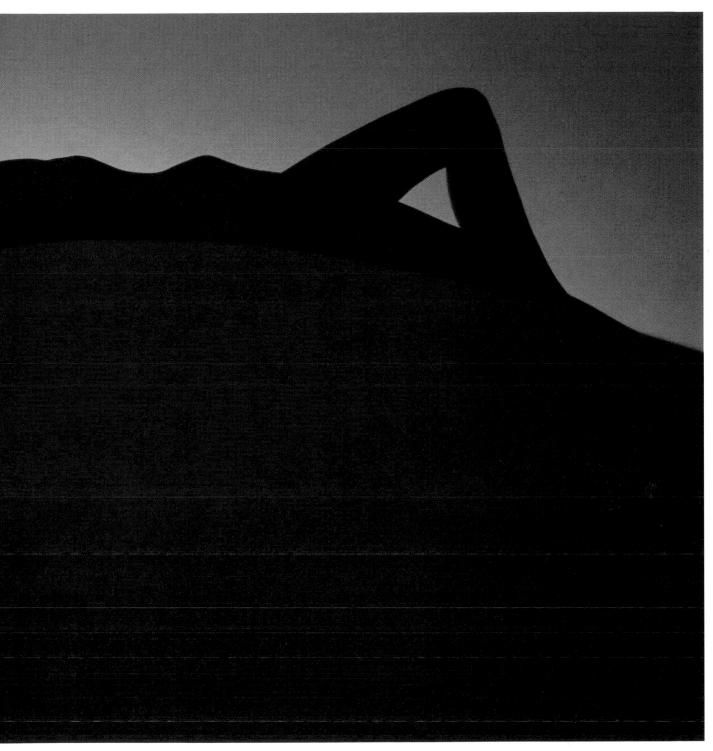

The outline of the body is
beautiful in its stark simplicity.
The model was sunbathing on
the roof of her hotel,
silhouetted by a richly coloured
African sunset. The curve of
the roof makes her look as if
she is stretched out over the
globe. A clear profile and a
good separation of legs and arm
make this an artistic, yet
simple, photograph. The
picture is timeless and has clear
areas of black, both of which
make it a good library picture
for possible commercial use.

A VARIETY OF ANGLES

Nude photography does not have to be posed. Off-guard moments can provide good pictures. This model was relaxing after a long photo session, but the alert photographer spotted a picture. It is a natural, uncontrived pose that would probably never have been tried during the session.

Add a simple prop. The use of a designer hat transforms this rear view of a nude on a Tunisian beach into a striking photograph. Strong sunlight throws a stark shadow on the sand and adds interest. Without the hat, the picture would not work, but the addition of this one outrageous prop, together with the graphic use of the shadow, makes this a fascinating study. The photographer has resisted the temptation to crop in close on the picture and has used the space to good effect.

The use of simple props makes this a great picture. A yellow turban and boldly patterned belt are all that adorn the model's naked body as she sits amid the ruins of a castle. This was a good subject in itself, but the addition of the model's mirror, cleverly placed so that she could see the camera in it and therefore appears to be looking at the photographer, creates an intimate feeling. Keep it simple was the rule here, but the mirror not only fills an empty space in the frame but gives the picture much greater impact.

PHOTOGRAPHING ANIMALS

Animal photography is something of a paradox. You may have to lie in wait for hours to get the chance of a good picture, but once the action begins, your reactions must be lightning quick, or you will miss that chance.

Whether they are your pets at home, wild animals in the country or exotic creatures in zoos or safari parks, animals are a constant source of inspiration and challenge to the photographer. And opportunities to photograph them are endless. Problems will arise if you do not appreciate the basic and seemingly obvious fact: animals do not pose for pictures. You must watch for the right moment and grab it when it occurs. Many's the time a photographer is still loading film when an animal decides to do something worth photographing — and it rarely repeats the performance.

So with animal photography, you must be quick — to focus, quick to release the shutter, and quick to anticipate what might happen next. He who hesitates will lose a good picture; with animals as subjects, it is always worth taking a few extra frames.

Occasionally you may be able to control the situation in the wild by putting food down to attract an animal's attention. This is not always desirable or even safe, but it can sometimes give you a chance you would not otherwise have. At zoos, or in parks where you are obliged to keep car windows closed, hold the camera close to the fence or glass to eliminate unwanted lines or reflections.

Although you should try to get as close as possible, never cross safety fences without authorization. No picture is worth injury, and you will only set a bad example to other visitors. Staff in zoos and parks are usually sympathetic to a photographer's requirements. If you are in doubt about where you are permitted to go, ask them.

Let patience be your watchword, especially when photographing animals in the wild. You may feel you are waiting an eternity, but the reward of a good wildlife picture will make it worthwhile. Whatever the animal or the location, once you have waited, quick wits and decisive action can give you some great pictures.

A lioness basking in the afternoon sun provides a majestic animal portrait. By using a wide aperture to reduce the depth of field and placing the camera right against the mesh fencing, the wire has been eliminated and the background thrown out of focus. This splendid creature could, therefore, be anywhere: in a zoo or on the African savannah. A telephoto lens would reduce the depth of field even further and concentrate attention on the lioness's head.

IN THE WILD

This wolf was taken at close quarters in a wildlife park which provided a chance to take pictures without wire fencing getting in the way. In such a situation, you must obey notices and the instructions of staff. It is useful to have at least one person with you to spot other animals and to watch out for danger.

Mirror the subject in the background. This blue heron wading in the shallows off the Florida Keys was photographed at water level with a 500mm lens. The background is well out of focus, but the aerial roots of the mangrove tree can still be seen and mirror the bird's long neck. The heron's colour, too, is reflected in the water. In this way the bird appears at one with its surroundings.

Making something out of nothing is possible with a little imagination. With its clever camouflage, this gecko on a screen door at Lion Country Safari in Florida was almost invisible from the outside. But the thinking photographer went inside the building and, with the camera close to the mesh, created an interesting silhouette of the tiny creature. This is one way to photograph colourless or small animals successfully.

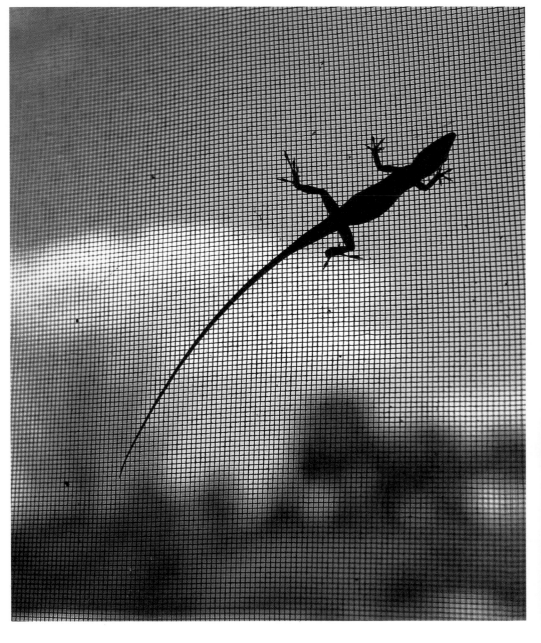

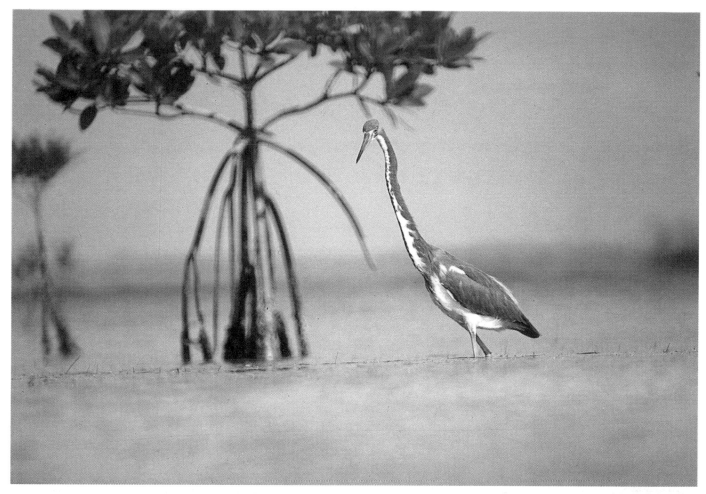

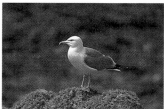

Wait for the action. In this instance, the photographer waited until the seagull called to its mate, then reacted swiftly, transforming a still-life into a lively study. It is well worth being patient when photographing animals in order to turn an ordinary, static picture into one that captures the nature of the beast.

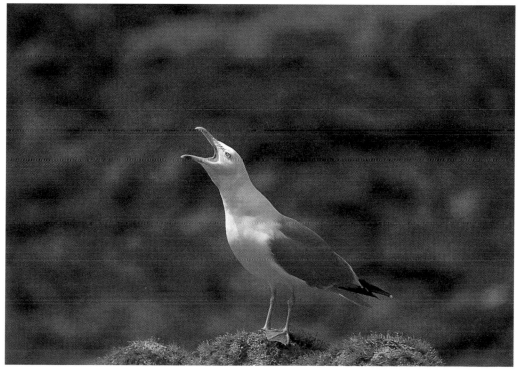

PICTURES THAT DON'T EXIST

We have all seen the pictures that don't exist — the full moon over such-and-such a place that you suspect was rather more than a coincidence, or the bizarre fantasy image that you are certain was a product of the photographer's mind rather than reality. Cheating this may be, but is it not the logical conclusion of the thinking photographer's creative imagination?

Such pictures are not merely the result of the camera seeing things differently from the naked eye, or the behaviour of the film altering the way a scene appears. The pictures that don't exist are created in many different ways, sometimes within highly specialized laboratories. Other images are far easier to produce. Double or multiple exposure is a common technique, and the sandwich transparency is another: here, two or more images are literally sandwiched together and re-photographed to produce a new picture.

This type of photography can be used to great effect, but it should be used sparingly. The simple techniques shown here can be taken to inordinately complicated lengths with modern-day computer technology. Truly 'impossible' images can be created — at a price, of course. Any photographer can use the methods demonstrated here to create a photographic fantasy.

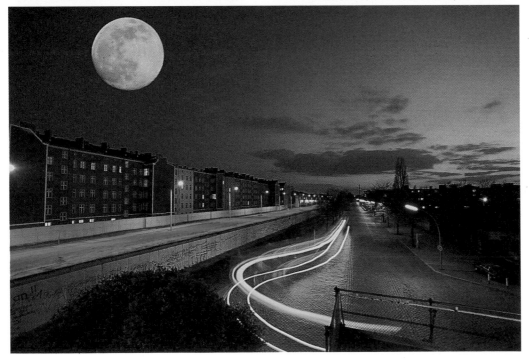

The addition of the moon or sun can break up a large expanse of sky in a landscape shot. This night view of the Berlin Wall, taken from one of the towers along its length, shows well the barrier between East and West. The photographer waited for an approaching bus, the lights of which add interest to the foreground, but there was rather too much sky on this moonless night. A bright full

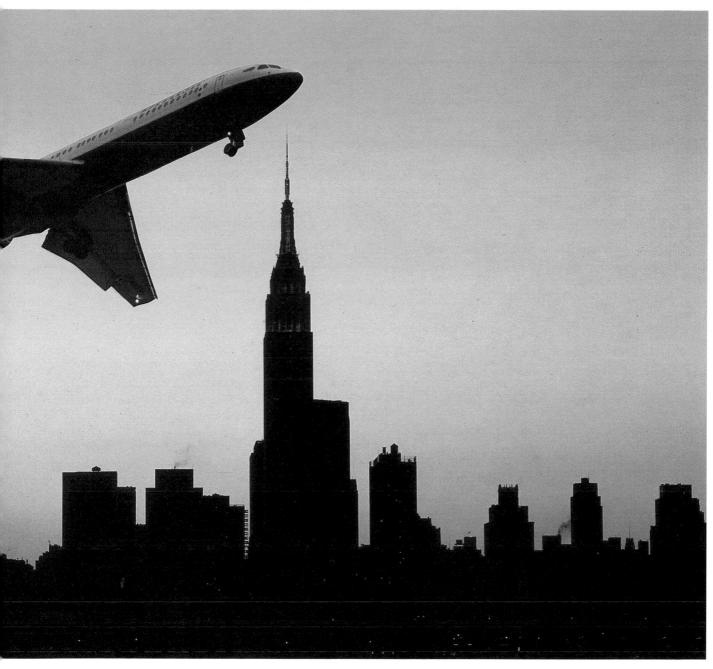

moon a week later provided the answer. The film of the Wall was run through the camera again, this time exposing for the moon and locating it in the top left-hand corner of the picture. The two frames above show the single component images, while below is the new double exposure — a much more interesting picture.

The sandwich transparency technique was used to produce this dramatic picture of a British Airways jet flying over New York. First, the plane was photographed on its final approach to Heathrow Airport in London. Then, the evening urban landscape was taken from the Brooklyn side of the East River in New York. The two images were sandwiched together and re-photographed to produce the new image

shown here. This technique of creating images enables the photographer to manipulate the component parts of a picture to alter scale and perspective.

THE HUMOROUS VIEW

A sense of humour is invaluable to a thinking photographer. Whether he is creating a funny picture by carefully controlling a situation or merely observing some humorous facet of the life going on around him, the photographer is in a unique position to record such moments. So always be on the lookout for the humorous situations that arise every day.

The secret of good humorous photography is planning and anticipation, or both. Some funny things just happen, as we saw earlier on in this book at Cruft's (see page 10) and in London's Kings Road (see page 16); others have to be created from an idea.

The advent of the auto-focus camera produced a new breed of *paparazzi* photographers, who stalk the famous wherever they may be. Photographic technique is almost non-existent in these instances — the camera does virtually all the work — but the operator must have the knack of being in the right place at the right time (or wrong, depending on which end of the lens you are). The results can be highly amusing, especially if the subjects are rich and famous, but the unfortunate victims may not share the photographer's sense of what is funny. If you want to sell your pictures, you should make sure the humour is gentle and inoffensive.

Unintentional humour can often be the funniest. This BMX bike champion had set up his ramps near a disused airfield in order to practise his jumps. By careful positioning, the photographer was able to build a humorous caption into the picture, transforming an ordinary action shot showing the rider's advanced technique into a photograph that can raise a smile as well.

Spotting the funny side of an everyday situation can also produce some great humorous photographs. Only top dogs are exhibited at Cruft's Dog Show in London, and for this lonely labrador it was a long, cold wait as his owner visited the show to see some rather finer specimens. There is gentle humour in this photograph as well as a sharp social comment on the British attitude to their animals.

There is no funnier subject than photographers themselves. Some will go to any lengths to get the right angle, and it can be a rewarding exercise to observe your colleagues as they strive for perfection. A collection of pictures of photographers in action holds a lesson for us all. Techniques range from the casual, one-handed approach to the over-zealous enthusiast, dripping with far too much photographic 'jewellery', in a perpetual search for the elusive 'big one'. All the equipment in the world, however, is no good if you cannot think a picture through in the right way.

BLACK AND WHITE

Many photographic experts agree that there is no picture quite as powerful as a good black and white image. Wars and other human tragedies are classic instances in which the impact of monochrome leaves colour floundering. Sebastiao Salgado's award-winning photographs of the African famine, for instance, put colour pictures in the shade. And in newspapers, of course, black and white is *the* medium in which the photographer must work.

The greater proportion of photography today is, however, in colour. Photographers contend that it is much more difficult to work in black and white, and it certainly does require a different awareness. Contrasting colours may merge into the same tones in monochrome, and working in a negative medium gives the photographer different exposure problems. With colour the general rule is 'when in doubt, underexpose', with black and white the opposite is true.

The photographer has much more control over the end result with black and white. A print can be worked on in the darkroom. Skies can be printed in or held back, for example, and highlights can be controlled by means of multi-grade systems of paper. The whole exposure latitude is far wider with black and white photography, but this does not excuse bad techniques.

If the advice is 'keep it simple' in colour, it is even more so in monochrome. Black and white photographs are at their best when graphically simple. Tonal separation must be clear, and although a great deal is possible in the darkroom, the photographer must have a good idea of the result he requires before he starts shooting. It is inexcusable to rely on the printer to come to the rescue if your technique is bad. A printer should be able to enhance a great picture, although he can, and often has, saved a photographer from disastrous results. The world's great printers should, however, be given the world's best negatives to work from.

If ever you find yourself taking pictures alongside professional photographers, you may pick up some tips by watching how they think ahead. When President Reagan visited Britain in June 1982, he was invited to go riding with the Queen at Windsor Castle. There was a photo-call for the world's Press, but as the heads of state sat astride their horses, the scene looked posed and lacking in atmosphere.

I remembered the President riding into the sunset in his movie days and could imagine the couple moving off — into the sunrise in this instance. So I took a chance and went to the extreme end of the press line-up and waited. It was a gamble, since a 'safety shot', the head-on view, was not possible from there. The Queen and the President did move off in the right direction, but with a party of other riders. However, with a long lens (300mm), there was a brief moment when I could cut out the other horses. A fast shutter speed was possible due to the speed of the black and white film, so the camera could be hand-held. The back view is unmistakably that of the Queen and the President of the United States. A bit of quick thinking and a little luck gave me a unique photograph.

PRINTING EFFECTS

A good printer can make a good photograph great. This picture — part of a black and white photo-essay on the decay of British seaside resorts — is a good example of this. It was taken at Skegness on England's east coast and shows a beach-ride cart looking for customers along the deserted shore. The broken-down pier beyond completes the story.

The straight print from the negative is shown below, but on the left is the final result. A more contrasty paper and careful printing of the sky and foreground create a picture with eye-catching impact. One simple image tells the whole story of the sorry state of this seaside town, and the printing has given it a stark reality. The photographer helped the printer in this instance by using a red filter which, with black and white film, makes a blue sky much blacker while keeping the clouds white, thus increasing contrast. But, in the end, it was superb printing that made this picture.

THE GRAPHIC IMAGE

Black and white film can give a stark, graphic quality to an image that is enhanced by good, creative printing. Looking for a lead picture for a photo-essay on West Point Military Academy in the United States, the photographer came across this imposing statue framed by an archway. This could just as easily have been taken by a tourist, however. What was needed was a figure to set the whole thing off. A marching cadet came to the photographer's rescue and injected the required military flavour. The right moment to take the shot was when the cadet was outlined against the white stone of the statue's base. There was only time for one shot.

When the picture was printed, detail in the archway was eliminated by printing it to a solid black. This made a strong frame for the marching soldier, focusing attention on the action. The human figure, dwarfed by the statue, also gives the viewer a good sense of scale.

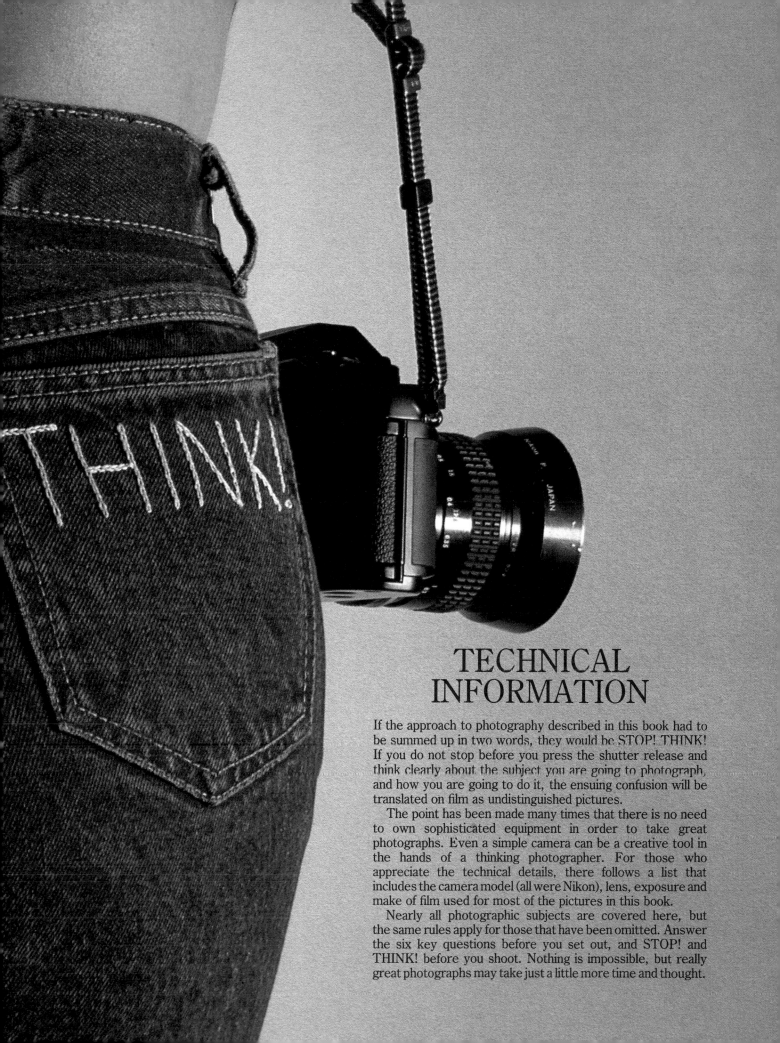

TECHNICAL INFORMATION

If the approach to photography described in this book had to be summed up in two words, they would be STOP! THINK! If you do not stop before you press the shutter release and think clearly about the subject you are going to photograph, and how you are going to do it, the ensuing confusion will be translated on film as undistinguished pictures.

The point has been made many times that there is no need to own sophisticated equipment in order to take great photographs. Even a simple camera can be a creative tool in the hands of a thinking photographer. For those who appreciate the technical details, there follows a list that includes the camera model (all were Nikon), lens, exposure and make of film used for most of the pictures in this book.

Nearly all photographic subjects are covered here, but the same rules apply for those that have been omitted. Answer the six key questions before you set out, and STOP! and THINK! before you shoot. Nothing is impossible, but really great photographs may take just a little more time and thought.

All the photographs in this book were taken with Nikon equipment. The main picture on a page is indicated by an asterisk (*). The positions of other pictures on a page are detailed where relevant; otherwise, information applies to all pictures on a page.

PAGE	CAMERA MODEL	LENS	FILM (ASA)	EXPOSURE
Jacket front	F3	15mm	Kodachrome 64	1/250 sec, f-8
8-9*	F3	500mm	Ektachrome 64	1/125 sec, f-8
10-11*	F3	55mm macro	Tri-X	1/125 sec, f-4
12-13*	F3	50mm	Ektachrome 64	4 secs, f-11
14-15*	F3	80-200mm zoom	Kodachrome 64	1/500 sec, f-11
16-17*	FM2	80-200mm zoom	Fuji 100	1/250 sec, f-5.6
18-19*	F3	6mm fisheye	Kodachrome 64	1 sec, f-8
20-21	FTN Nikkormat	200mm	Tri-X	1/250 sec, f-5.6
22 (above)	F3	35mm	Ektachrome 64	1/60 sec, f-8
(below)	F3	35mm	Ektachrome 64	1/125 sec, f-11
23	F3	500mm	Kodachrome 64	1/500 sec, f-8
24	F3	24mm	Kodachrome 64	20 secs, f-11
25	F3	500mm	Kodachrome 64	2 mins, f-8
26 (above)	FM2	24mm	Kodachrome 64	1/2000 sec, f-11
(below)	F3	300mm	Ektachrome 64	1/500 sec, f-8
27	F3	105mm	Kodachrome 64	1/125 sec, f-4
28-29	F3	15mm	Tri-X	1/60 sec, f-5.6
30	FM2	55mm	3M 1000	1/250 sec, f-5.6
31	FM2	55mm	Fuji 100	1/125 sec, f-4
32-33*	FM2	55mm	Fuji 400	1/15 sec, f-8
34-35*	FM2	55mm	Ilford XP1	1/125 sec, f-5.6
36-37	FM2	55mm	Fuji 100	1/60 sec, f-4
38-39*	FM2	55mm	Fuji 400	1/250 sec, f-2.8
40-41	FM2	55mm	Ektachrome 64	open shutter, f-5.6
42 (above)	FM2	55mm	Ektachrome 64	1/250 sec, f-4
(below left)	FM2	55mm	Fuji 100	1/125 sec, f-4
(below right)	FM2	55mm	Tri-X	Electronic flash, f-16

PAGE	CAMERA MODEL	LENS	FILM (ASA)	EXPOSURE
43 (*above*)	FM2	55mm	Ilford XP1	Electronic flash, *f*-22
(*below*)	FM2	55mm	Ektachrome 64	Electronic flash, *f*-5.6
44	FM2	35mm	Tri-X	1/30 sec, *f*-5.6
45	FM2	35mm	Fuji 100	1/125 sec, *f*-5.6
46-47	FM2	105mm	Fuji 50	Electronic flash, *f*-11
48 (*above and below left*)	FM2	35mm	Fuji 100	1/125 sec, *f*-5.6
(*below right*)	FM2	300mm	Fuji 100	1/125 sec, *f*-5.6
49 (*above*)	FM2	300mm	Fuji 100	1/125 sec, *f*-5.6
(*below*)	FM2	105mm	Fuji 100	1/125 sec, *f*-5.6
50-51*	FM2	55mm	Ektachrome 64	1/500 sec, *f*-8
52-55	FM2	55mm	Ektachrome 64	1/250 sec, *f*-4.5
56-57*	FM2	105mm	Fuji 100	1/125 sec, *f*-5.6
58-62	F3	55mm	Fuji 100	1/30 sec, *f*-5.6
63*	F3	55mm	3M 1000	1/125 sec, *f*-5.6
64-65	FM2	80-200mm zoom	Kodachrome 64	1/250 sec, *f*-8
66 (*left*)	F3	35mm	Fuji 100	Electronic flash, *f*-8
(*right*)	F3	35mm	Fuji 100	Electronic flash, *f*-5.6
67 (*above*)	F3	35mm	Fuji 100	1/250 sec, *f*-11
(*below*)	F3	35mm	Fuji 100	Electronic flash, *f*-8
68*	F3	105mm	Fuji 100	1/500 sec, *f*-4
69*	F3	55mm	Fuji 100	1/125 sec, *f*-5.6
70 (*above and centre*)	F3	80-200mm zoom	Fuji 100	1/250 sec, *f*-4.5
70 (*below*)	F3	105mm	Fuji 100	1/500 sec, *f*-4
71 (*above*)	F3	105mm	Fuji 100	1/60 sec, *f*-4
(*below left*)	F3	105mm	Fuji 100	1/125 sec, *f*-5.6
(*below right*)	F3	35mm	Fuji 100	1/125 sec, *f*-5.6
72-73 (*above*)	F3	80-200mm zoom	Fuji 100	1/125 sec, *f*-4.5
(*below*)	F3	105mm	Fuji 100	1/250 sec, *f*-4
74	F3	300mm	Fuji 100	1/250 sec, *f*-5.6
75 (*above*)	F3	300mm	Fuji 100	1/250 sec, *f*-5.6
(*below left*)	F3	200mm	Fuji 100	1/250 sec, *f*-5.6
(*below right*)	F3	24mm	Fuji 100	1/500 sec, *f*-11
76*	F3	300mm	Fuji 100	1/250 sec, *f*-4.5
77 (*above*)	F3	80-200mm zoom	Fuji 100	1/250 sec, *f*-5.6
(*below*)	F3	200mm	Fuji 100	1/250 sec, *f*-4.5

PAGE	CAMERA MODEL	LENS	FILM (ASA)	EXPOSURE
78 (above and below left)	F3	300mm	Fuji 100	1/250 sec, f-5.6
(below right)	F3	200mm	Fuji 100	1/250 sec, f-8
79 (above)	F3	105mm	Fuji 100	1/125 sec, f-4
(below)	F3	80-200mm zoom	Fuji 100	1/250 sec, f-5.6
80-81*	FM2	55mm	Fuji 100	Electronic flash, f-8
82-83*	FM2	80-200mm zoom	Fuji 100	1/250 sec, f-5.6
84 (above)	FM2	105mm	Fuji 400	1/125 sec, f-2.8
(below)	FM2	55mm	Fuji 100	1/125 sec, f-5.6
85 (above)	FM2	55mm macro	Fuji 100	1/125 sec, f-4
(below)	FM2	55mm	Fuji 100	Electronic flash, f-8, with filter
86-87*	FM2	80-200mm zoom	Kodachrome 64	1/60 sec, f-8
88-89	FM2	105mm	Fuji 100	Electronic flash, f-5.6, then 2 secs at f-8
90-91	F3	300mm	Fuji 100	1/500 sec, f-5.6
92-93	FM2	35mm	Fuji 100	Electronic flash, f-11
95 (above left and right)	F3	300mm	Fuji 100	1/500 sec, f-8
(below)	F3	200mm	Fuji 100	1/250 sec, f-8
96-97 (above)*	F3	500mm mirror	Fuji 100	1/2000 sec, f-8
(below)*	F3	105mm	Fuji 100	1/8 sec, f-22
98	F3	300mm	Fuji 100	1/500 sec, f-4.5
99	F3	80-200mm zoom	Fuji 100	1/15 sec, f-16
100-101*	F3	15mm	Fuji 100	1/500 sec, f-8
102-103	F3	55mm	Kodachrome 64	1/2 sec, f-8
104	F3	180mm	Kodachrome 64	1/15 sec, f-16
105 (above)	F3	200mm	Kodachrome 64	1/250 sec, f-4 } with polarizing
(below)	F3	200mm	Kodachrome 64	1/4 sec, f-32 } filter
106 (above left)	F3	80-200mm zoom	Kodachrome 64	1/250 sec, f-4.5
(below left)	F3	80-200mm zoom	Kodachrome 64	10 secs, f-11
(above right)	F3	80-200mm zoom	Kodachrome 64	Electronic flash, f-8
107	F3	80-200mm zoom	Kodachrome 64	1/15 sec, f-5.6, during zoom
108-109	F3	24mm	Fuji 50	4 secs, f-8
110*	FM2	35mm	Kodachrome 64	1/125 sec, f-8
111*	FM2	200mm	Kodachrome 64	1/250 sec, f-4
112*	FM2	200mm	Kodachrome 64	1/250 sec, f-5.6
113*	FM2	55mm	Kodachrome 64	1/125 sec, f-11

PAGE	CAMERA MODEL	LENS	FILM (ASA)	EXPOSURE
114 (*above*)	FM2	35mm	Kodachrome 64	1/125 sec, *f*-8
(*below*)	FM2	35mm	Kodachrome 64	1/250 sec, *f*-8
115	FM2	55mm	Kodachrome 64	1/250 sec, *f*-5.6
116 (*above*)	FM2	80-200mm zoom	Kodachrome 64	1/60 sec, *f*-8
117	FM2	80-200mm zoom	Kodachrome 64	1/30 sec, *f*-5.6 with polarizing filter
118-119	FM2	105mm	Fuji 50	1/15 sec, *f*-5.6
119 (*above*)	FM2	105mm	Fuji 50	1/4 sec, *f*-5.6
120 (*above*)	FM2	105mm	Fuji 50	1/125 sec, *f*-5.6
(*below*)	FM2	105mm	Fuji 50	1/250 sec, *f*-8
121 (*above*)	FM2	105mm	Fuji 50	1/250 sec, *f*-8
(*below*)	FM2	105mm	Fuji 50	1/500 sec, *f*-8
122-123*	F3	35mm	Kodachrome 64	1/500 sec, *f*-11
124 (*above*)	F3	200mm	Kodachrome 64	1/125 sec, *f*-8
(*below left*)	F3	35mm	Kodachrome 64	1/60 sec, *f*-5.6
125 (*above*)	F3	35mm	Kodachrome 64	1/125 sec, *f*-5.6
(*below*)	F3	105mm	Kodachrome 64	1/250 sec, *f*-5.6
126-127	F3	15mm	Kodachrome 64	1/8 sec, *f*-8
128*	FM2	55mm	Kodachrome 64	1/60 sec, *f*-5.6
129	F3	80-200mm zoom	Fuji 100	1/250 sec, *f*-8
130-131*	FM2	15mm	Kodachrome 64	1/125 sec, *f*-8
132-134		*not recorded*		
135	FM2	24mm	Kodachrome 64	1/500 sec, *f*-11 with polarizing filter
136*	F3	200mm	Kodachrome 64	1/250 sec, *f*-8 with polarizing filter
137*	FM2	35mm	Kodachrome 64	1/250 sec, *f*-11
138 (*below*)	F3	105mm	Kodachrome 64	1/500 sec, *f*-8
139	F3	15mm	Kodachrome 64	1/500 sec, *f*-11
140 (*above*)	F3	105mm	Kodachrome 64	1/250 sec, *f*-5.6
(*below*)	F3	105mm	Kodachrome 64	1/125 sec, *f*-5.6
141 (*above*)	F3	105mm	Kodachrome 64	1/500 sec, *f*-5.6
(*below*)	F3	55mm	Kodachrome 64	1/125 sec, *f*-8
142 (*above*)	F3	105mm	Kodachrome 64	1/250 sec, *f*-8
(*below*)	F3	105mm	Kodachrome 64	1/250 sec, *f*-5.6
143	F3	35mm	Kodachrome 64	1/250 sec, *f*-8

PAGE	CAMERA MODEL	LENS	FILM (ASA)	EXPOSURE
144	AF35	35mm	Kodachrome 64	Automatic, with flash
145	F3	15mm	Fuji 100	1/30 sec, f-8
146 (above) (below)	F3 F3	85mm 105mm	Fuji 100 Fuji 100	1/125 sec, f-5.6 1/500 sec, f-5.6
147	FM2	105mm	Kodachrome 64	1/250 sec, f-8
148-149*	F3	85mm	Kodachrome 64	1/125 sec, f-5.6
150-151	F3	105mm	Fuji 100	1/250 sec, f-8
152-153*	F3	35mm	Kodachrome 64	1/250 sec, f-8
154		*not recorded*		
155	F3	500mm	Kodachrome 64	1/500 sec, f-8
156-162	FM2	55mm	Ektachrome 64	various
163	FM2	200mm	Ektachrome 64	1/125 sec, f-5.6
164-165*	F3	24mm	Ektachrome 64	1/250 sec, f-5.6
166 (below)	F3	24mm	Ektachrome 64	1/500 sec, f-11
167	F3	35mm	Ektachrome 64	1/60 sec, f-5.6
168-169	F3	200mm	Ektachrome 64	1/125 sec, f-4.5
170 (above) (below)	F3 F3	135mm 55mm	Ektachrome 64 Kodachrome 64	1/125 sec, f-5.6 1/500 sec, f-8
171 (above) (below)	F3 F3	500mm 500mm	Kodachrome 64 Kodachrome 64	1/500 sec, f-8 1/250 sec, f-8
172 (above left) (above right)	F3 F3	500mm 24mm	Fuji 100 Fuji 100	1/30 sec, f-8 8 secs, f-8
173		*not recorded*		
174 (below)	FM2	35mm	Tri-X	1/125 sec, f-5.6
174-175*	FM2	35mm	Fuji 100	1/250 sec, f-8
175	FM2	80-200mm zoom	Kodachrome 64	1/250 sec, f-4.5
176-177	F3	300mm	Tri-X	1/500 sec, f-4.5
178-179*	F3	55mm	Tri-X	1/125 sec, f-8, with red filter
180-181	F3	105mm	Tri-X	1/250 sec, f-8
182-183	F3	105mm	Fuji 50	Electronic flash, f-11

against the light when the subject is between the photographer and the light source, so as to be back-lit.

angle of view the position of the camera in relation to the subject, or the angle 'seen' by a given lens.

aperture an adjustable hole in the iris of the lens that opens and closes by means of a system of metal leaves and allows light to pass through onto the film. The size of the hole, or aperture, is defined in f-stops.

ASA (American Standards Association) the rating of the sensitivity of a film to light, which determines the exposure setting. The faster, or more sensitive, the film, the higher the ASA number.

auto-focus describes a camera that focuses automatically on a subject in the viewfinder (usually by means of infra-red light), without any manual adjustment.

automatic camera one in which the exposure is controlled automatically by built-in components. A semi-automatic camera requires the user to select the aperture setting or the shutter speed.

available light existing natural light without supplementary lighting.

burning out describes what happens when the range of the film is inadequate to cope with bright highlights, with the result that detail is lost in these areas due to overexposure.

cast any overall colour tone affecting the film, often due to the use of a particular light source or to the photograph being taken either early or late in the day.

colour negative film used for producing colour prints. This film records colours as their complementaries (complementary colours, eg blue and yellow, are pairs of colours which when mixed together as light beams of the right intensity, will produce white light). The complementary colours are reversed in the printing to give the original colours.

colour reversal film used for producing colour transparencies (slides). This film gives a positive transparency by 'reversing' the negative image during processing.

colour saturation the density and strength of colour.

colour transparency film see colour reversal film.

contrast the degree of difference between light and dark tones in an image. When there is a wide difference, a photograph is described as 'contrasty'; when there is not much difference, it is described as 'flat'.

cropping the framing of a photograph in the camera as the shot is taken, or selecting only part of a photographic image for printing or enlarging.

depth of field the area of a photograph that appears acceptably sharp in front of and behind the point on which the lens is focused.

double exposure one or more exposures made on the same piece of film, resulting in the imposition of one image on another.

exposure depends on the amount of light that reaches the film. It is determined by the combination of aperture setting, which controls the intensity or amount of the light, and shutter speed, which controls the exposure time.

fast film film with a rating of 200 ASA or more.

fisheye lens one with an angle of view of 180° or more; it often produces a circular image.

flare produced when a bright light shines directly on the lens, either projecting the shape of the aperture onto the image or causing a loss of colour due to overexposure.

f-stop/number refers to the size of the aperture through which light passes to the film. The lower (smaller) the number, the wider the aperture and thus the more light that will strike the film.

focal length the distance between the optical centre of the lens, when focused on infinity, and the film plane. The longer the focal length, the narrower the angle of view.

gelatine filter a transparent material, of several different colours, that absorbs some wavelengths of light passing through it. It is placed in front of the lens to change the colour balance of the light or to create a special effect.

graininess the granular effect that appears on fast film due to its increased sensitivity. The faster the film, the coarser the grain.

high key describes a photograph of predominantly light tones in which the highlights may be bleached out, due to overexposure, so there is no detail in the shadows.

highlights the brightest parts of a photograph.

latitude describes a film's degree of tolerance to exposure variations that will still produce an acceptable result. Usually, the faster the film, the greater its latitude.

low key describes a photograph of predominantly dark tones, often due to underexposure, in which there are deep shadows and no bright highlights.

macro lens one capable of focusing extremely close to a subject; a close-up lens.

mirror lens one using concave mirrors instead of a straight-through lens system, so that light rays are reflected up and down the lens tube before reaching the film. The mirror lens is light and portable, but has a fixed aperture. The out-of-focus 'doughnut' effect often seen on highlights is produced by such a lens.

overexposure results when too much light reaches the film, so that the image is too light and lacks contrast; highlights may be bleached out and show no detail.

pan and tilt head a tripod mechanism that allows the camera to swing and tilt through 180° or more.

panning following the motion of a subject with the camera and releasing the shutter during the swing of the camera. In this way, a slower shutter speed can be used to keep the subject sharp while blurring the background to give the effect of movement and/or speed.

plate camera a large-format camera which originally used glass plates coated with emulsion instead of cut film.

polarizing filter a filter used to cut out reflections and haze by reducing polarized light. Used on a blue sky, it deepens the colour, increasing the contrast between sky and clouds.

reciprocity failure the alteration of the colour balance of a film during extremely long or short exposures because the normal relationship between exposure and light intensity does not then apply.

self-timer mechanism a camera control that delays the firing of the shutter after the release button is pressed. It enables the photographer to make last-minute adjustments or to move into the picture himself.

shutter the device on a camera that controls the length of time of

the exposure, so determining the amount of time during which the film is exposed to the light.

slow film film with a rating of 100 ASA or less, giving fine grain and good definition.

SLR (single lens reflex) a camera in which a mirror, set at an angle behind the lens, reflects the image up to the viewfinder. The mirror swings out of the way when the shutter is released. The user sees through the viewfinder the exact image that will be reproduced on film.

soft focus describes an image that has been diffused by filters or by shooting through glass or other materials to reduce the overall sharpness of the picture. This technique is often used to soften skin tones or smooth out any blemishes.

standard lens one with a focal length approximately equal to the diagonal of the format for which it is intended. For a 35mm camera, it is generally 50-55mm.

stopping down reducing the size of the aperture and thus the amount of light entering the camera. This has the effect of increasing the depth of field.

sync cord/synchronization lead the lead that joins a camera to a flash gun, to trigger the flash when the shutter is opened.

telephoto lens one with a longer focal length and a narrower angle of view than a standard lens. It permits focusing at greater distances from the subject and produces greater magnification; it is used to bring subjects closer without physically moving the camera nearer to them.

tungsten light artificial light, produced by a bulb containing a tungsten filament, which is much warmer in tone than daylight.

underexposure results when insufficient light reaches the film, so that the image appears very dark.

wide-angle lens one with a shorter focal length than a standard lens and a field of view of 60° or more. Used for photographing a wide area from close range.

zoom lens one that can be adjusted to a range of continuously variable focal lengths by sliding or rotating the barrel. Also known as a variable focus lens.

zooming moving a variable focus lens during an exposure, often to produce an 'explosion' effect.

INDEX

ACKNOWLEDGEMENTS

The author would like to thank the
following for their assistance in the
preparation of this book:

Ivy and Bill Allsopp
Jennifer Beeston
Jon Bigg
Bryn Campbell
Lyn Cullen
Gerry Davis (photograph p. 27)
Donald Binney (for Index)
Martyn Goddard
Tom Hawkyard / 3M
Jill Kennington
Leigh
Nigel Macintyre
Tony Martin (for black and white printing)
Vicki Michelle (for enduring the six
 photographers)
Julian Nieman
Graham Rutherford / Fuji
Gene Spatz
Lindsay and Ian Thomlinson
Patrick Thurston
Frances Vince

Alamo Car Rental
British Airways
Irish Tourist Board
Lion Country Safari
Nikon (UK) Ltd.
The Observer
Sunday Mirror
Telegraph Sunday Magazine
YOU magazine
Walt Disney Productions Ltd.

Artwork by Hayward and Martin